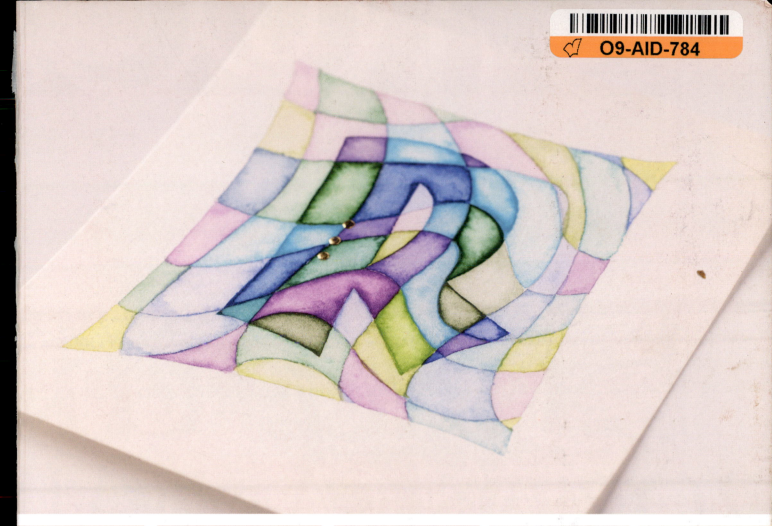

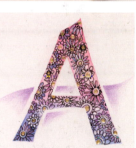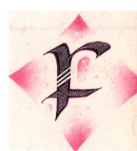

Decorated
Lettering

Dedication

For my two very special sons, Dan and Rhys; also my delightful granddaughter Ava.

My thanks to best friends Sue and Margot, for keeping my blood pressure at manageable levels during the enjoyable task of assembling this book!

Decorated
Lettering

Jan Pickett

SEARCH PRESS

First published in 2016

Search Press Limited
Wellwood, North Farm Road,
Tunbridge Wells, Kent TN2 3DR

Photographs by Paul Bricknell at Search Press Studios.
Additional photographs author's own

ISBN: 978-1-78221-155-6

The Publishers and author can accept no responsibility for
any consequences arising from the information, advice or
instructions given in this publication

Readers are permitted to reproduce any of the items in this
book for their personal use, or for the purpose of selling for
charity, free of charge and without the prior permission of the
Publishers. Any use of the items for commercial purposes is
not permitted without the prior permission of the Publishers

Suppliers
If you have difficulty in obtaining any of the materials and
equipment mentioned in this book, then please visit the
Search Press website for details of suppliers:
www.searchpress.com

Printed in China

Contents

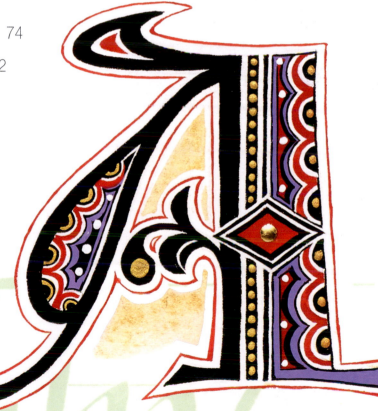

Introduction

Welcome to the wonderful world of lettering in all its forms – written, drawn, decorated and delicious! I love exuberantly coloured letterforms, as well as experimenting in order to use them for a wide range of applications. My approach to calligraphic and hand-drawn lettering in this book is to enhance designs with both traditional and contemporary decoration, making it visually exciting, interesting and appropriate to the subject matter.

Friends and family love receiving gifts and cards for important occasions and birthdays. These are made very special when they are handmade and personalised. This is a win–win situation, as you have the enjoyment of preparing the work, along with the pleasure of giving it to an appreciative response – a perfect goal for your calligraphic ventures.

The first section of this book covers the materials used throughout the various projects. There follows a section that covers and explains the main differences between pen-drawn and hand-drawn lettering. Eight calligraphic alphabets are illustrated, together with the required pen angles, common group structures and stroke order. Following these more traditional alphabets are a number of hand-drawn compound alphabets, patterns, embellishments and decoration for you to use in your own artwork. They are presented with helpful tips on layout and design, and supported by a clear explanation of both the art and the science of colour, so that you can make the very best of all of the techniques included here.

This book is a comprehensive course in all aspects of decorated lettering, suitable for beginners, experienced calligraphers and all those interested in the magical world of lettering. In fact, it is for everyone who loves letters. The designs I have had such pleasure in preparing for this book are inspired by the countless examples of western lettering from the past two thousand years: carved stone lettering from Ancient Rome, decorated mediaeval manuscripts, and the imaginative works of the Victorian era. Many of the examples in this book evolved through the sheer pleasure of playing and having fun with letters and experimenting with different materials.

Working through the chapters will help you achieve a wide range of versatile designs, using relatively simple forms of decoration, all of which are fun to do and fabulous to receive. These same decorative ideas can be readily adapted and applied to other designs, allowing you to create an infinite number of attractive designs. If all of this sounds interesting, then this is definitely the book for you.

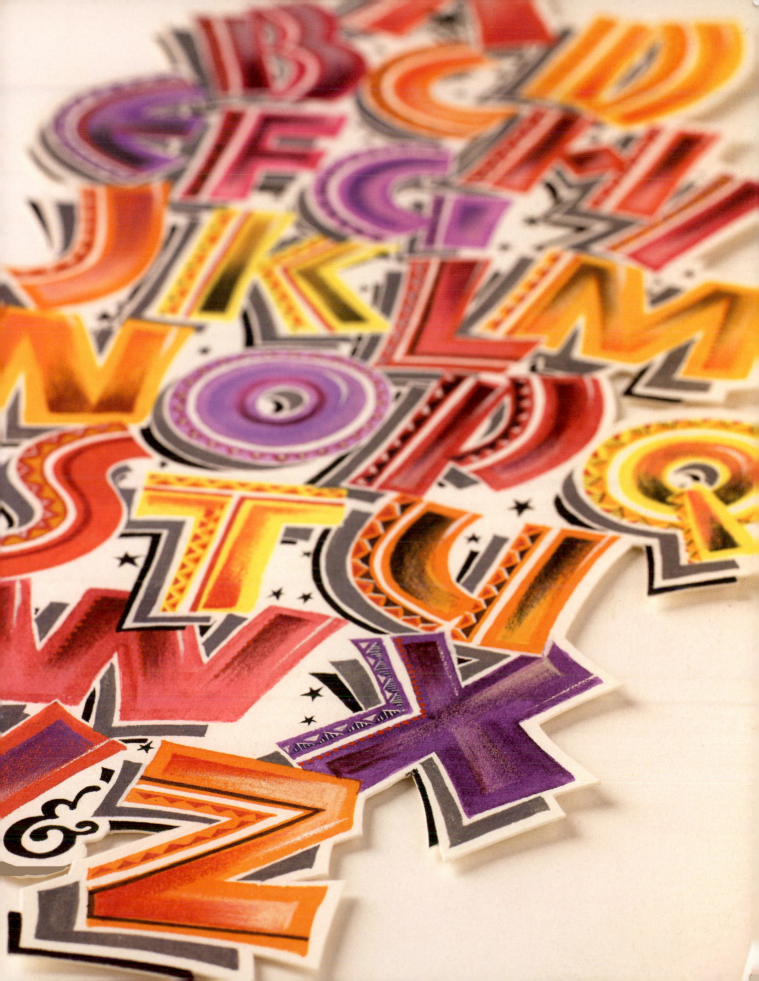

Materials

Whether you are new to lettering or very experienced, having the correct materials is important to achieving the desired end results. It is worth taking the time to familiarise yourself with the tools you will be using so that you are confident of the reasons why they are necessary.

The materials detailed on the following pages are those used for almost every type of calligraphy and decorated lettering. Where individual chapters require particular materials for the techniques included, specific details are explained there. All are readily available in dedicated art shops or online, so there are no excuses!

Papers

It cannot be over-emphasised that the quality and type of paper can very much influence the end result of your work, so it is vital that you always do trials on the exact paper you intend to work on in order to be confident of the end results.

There is a bewildering array of papers on the market and it is easy to feel overwhelmed by the choice available. They come in various weights, colours and surfaces. Most of the examples in this book use paper with a surface that is 'hot-pressed' (HP), which means it has been through several processes to make it perfectly smooth. Some use watercolour paper which has a textured surface, described as 'Not', which has a slight texture. Not simply means 'not hot-pressed'. Heavily textured watercolour paper, described as 'rough', is also occasionally used. The weight describes the thickness of the paper. For example, if marked as 250gsm (160lb), it means that a square metre of that particular paper weighs two hundred and fifty grams (the poundage refers to the weight of the paper ream – five hundred sheets). Heavier-weight papers tend not to stretch and cockle when wetted. The projects in this book generally use heavier-weight paper, as it is important that the paper does not stretch when it is wetted, which risks spoiling the results. My all-round preference for watercolour paper is Arches Aquarelle HP as it is perfect to write on, takes colour well and will also emboss. Look for these qualities in the paper you choose.

Papers for embossing need a soft surface which will yield to the pressure and not crack during the process. Printmaking papers are ideal; my preference is for BFK Rives which also takes watercolour beautifully. Somerset paper also embosses well. They are both produced to archival standards, so your work will not fade or degrade.

A variety of papers used for calligraphy and decorative lettering.

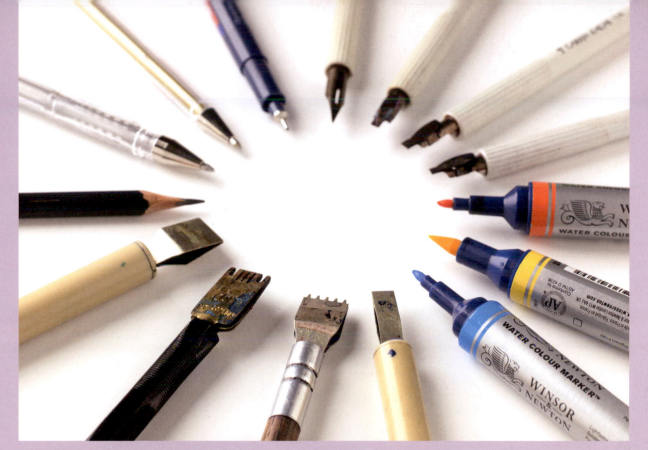

Writing and drawing materials

Pens

Edged pens come in many sizes and materials, including a wide choice of fibre tipped edged pens, all of which are fun to use and allow plenty of variety and creativity. Automatic pens, shown in the lower left of the picture above, include very broad nibs along with 'split' or 'scroll' nibs, which can be used to apply multiple lines at once. The five-line version was often used by musicians and composers to draw the musical stave.

Nibs

There are two main types of metal nibs available. The first type uses a reservoir to hold writing liquid, the second includes the various designs of Automatic and poster pens – the broad-edged nibbed pens illustrated above.

For quality and reliability, you cannot better metal nibs that are used with a reservoir that fits either under or on top of the nib (see right). My personal favourite, and the best value, are bronze nibs which come ready fitted with a top-loading reservoir. These are very easy to fill, making them a pleasure to use.

Pencils

Pencils come marked with a number and either H or B. The higher the number on an H pencil, the harder the lead. H stands for 'hard', which indicates more clay than graphite content in the lead. B stands for 'black', and indicates the opposite. For these pencils, the higher the number, the softer the lead. F pencils – the letter stands for 'fine' – are also available, which are similar to H grade pencils.

Pencils between 2H and 4H are ideal for lightly ruling lines that will not smudge. Those between 1B and 6B are good for drawing and shading. They are also very responsive, which makes them perfect for pressure and release techniques.

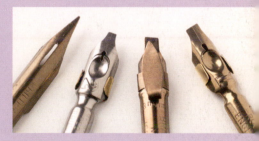

A selection of nibs

From left to right: pointed nib, edged nib with bottom-loading reservoir, edged nib with top-loading reservoir, left oblique nib with bottom-loading reservoir for left-handed calligraphers.

Brushes

As with pens, there are many brushes available. When choosing which sort you will use, bear in mind that you will get only what you pay for. Cheap brushes will not do you any favours, so I recommend the very best you can afford, as they will help you achieve your goals. I only ever use top quality sable brushes – sizes 0, 1 and 2 are a good starting point – and there are several excellent brands available.

Ensure that the hairs all come to a good point and store them with the little plastic protective tube over the brush head. Individual sable hairs are hollow and hold far more paint in one loading than a synthetic brush.

Brushes for writing normally have square-edged tips, which are used at an angle similar to a pen. However for the purposes of this book, the brushes are mainly pointed and for painting only.

Paint

Gouache and watercolour can be applied with a paintbrush or fed into a pen to create delightful results. Both types of paint consist of a pigment combined with gum arabic, a binder; and both can be diluted with water. The amount of pigment relative to the binder is greater in gouache than watercolour and as a result, watercolours are more translucent than gouache, which have greater covering power.

Designers' gouache is bought in tubes, while watercolours can be bought in tubes or in the form of hard blocks called pans. Both are equally good for the techniques in this book.

Qualities and brands vary greatly and I would always recommend buying artists' quality paints, as cheaper students' quality paints tend to contain fillers and extenders. Artists' quality paints are more permanent, more intense in their colour and show a superior degree of both transparency and opacity.

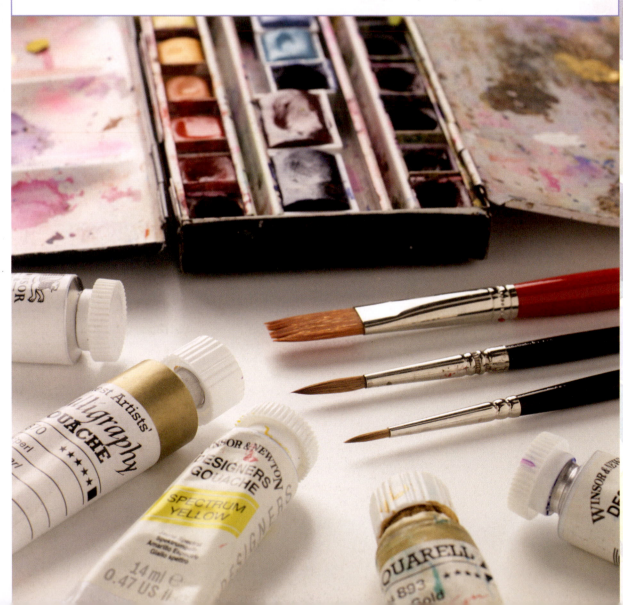

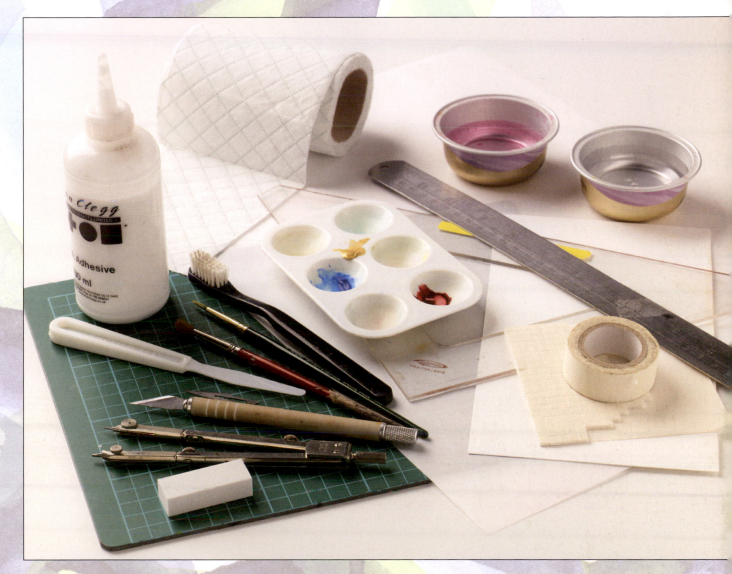

Other materials

Ruler, set square and dividers
These help to rule lines accurately.

Mixing brushes These brushes can be synthetic, but not too small, as they need to hold sufficient colour to fill pens as well as mixing. You can always use your 'retired' best brushes.

Toothbrush Pen nibs should be thoroughly cleaned after use. A toothbrush is a good way of helping get into recesses.

PVA glue Good quality, waterproof glue is used for gilding and as a general adhesive.

Palette knife This is perfect for mixing and spreading glue and paint.

Craft knife and cutting mat Ensure you have a sharp knife for cutting, along with some spare blades.

Sticky fixers These padded squares are used to give a raised effect when mounting lettering.

Masking and removable tape This is used to fix your paper securely to a drawing board.

Tracing paper Tracing paper allows you to duplicate letterforms easily for consistency.

Kitchen paper Have this on hand to mop up spills.

Scrap paper Protect your work by resting your hand on scrap paper as you write.

Mixing palette A clean white mixing palette is used to prepare watercolours and gouache paints.

Water pots Clean water is a must for bright, clean colours.

Enjoyment
Patience and a sense of humour are just as essential to success as any tool!

I will lift up mine eyes to the hills: from whence cometh my help

· PSALM 121 ·

Psalm 121

Flourished italic lettering was used to add impact and an elegant flow to this short biblical verse. Once the writing was complete, gentle background colouring was added to complement the text by rubbing in dry pastel, then 'drawing' rays of light using an eraser.

The art of lettering

The fascination and enjoyment gained from the study of beautiful lettering cannot be underestimated. It draws on a long and richly illustrated history and continues to be inspirational to this day.

Lettering and calligraphy

Lettering is simply the art of creating letters. Lettering can be hand-drawn; built up with pens, pencils, brushes and other tools. It can also be incised into stone, slate and wood.

Calligraphy is more specific. It is a form of lettering that involves specific strokes of an edged pen or brush. Held at a particular angle relative to the horizontal line, the movements of the pen produce the thick and thin strokes typical of the art.

Lettering and calligraphic writing form parts of an art which is an expression of ourselves. As with any art form, we begin with the basic, fundamental requirements and gradually make progress to personal goals on our calligraphic journey.

Historical skill and modern technology

Lettering, both calligraphic and graphic, can be a standalone skill. It can also benefit from being used alongside or in conjunction with modern technological advances.

Word processors can provide help through word count tools, and more exciting layout opportunities for your artwork appear when using a graphics editing program, such as Adobe's Photoshop, in conjunction with hand lettering. As with the hand-craft techniques in this book, experimentation in these fields is both fun and useful.

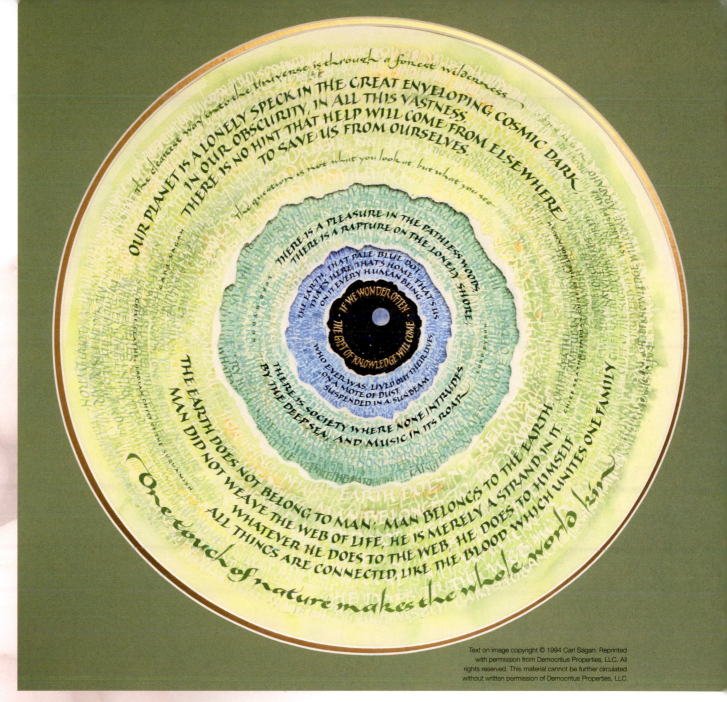

Universal Thoughts

This piece was inspired by the astronomer Carl Sagan, whose beautiful, humbling and dignified words surround a pale blue dot – the planet Earth.

 The background layers were written in masking fluid and coloured over with watercolour as detailed on page 116. On removal of the rubberised lettering, some extra background writing was added in watercolour to increase the contrast and interest. Finally, the main foreground writing was added using gouache.

Preparation

Comfort

When preparing any form of lettering, it is important to be sitting comfortably to be kind to your back. Good light is essential; ideally a natural light source from the left for a right-hander and from the right for a left-hander. While a flat surface is better for some forms of decorated work, you should work on a board which is at a slight angle when preparing calligraphic lettering.

Work on a slightly padded surface rather than directly onto a hard board and have a guard sheet (a spare piece of scrap paper will do) on which to rest your hand. This will help to catch any accidental drips and flicks of paint and stop grease transferring from the edge of your hand onto your paper surface.

Materials

Have your materials easily to hand as when the creative juices start, it is good to go with the flow. There is nothing worse than suddenly needing to hunt for something you need! In particular, when using gouache or watercolours, have several small pots of clean water available to thoroughly wash your brushes and to keep your colours and colour changes pure.

Papers have their own characters and can react in very different ways to the materials you use to write or decorate upon them, especially when using watercolour paints. For this reason, it is vital to have plenty of off-cuts of the paper your final piece is to be prepared on, so that you can practise on that particular surface before you start your final piece.

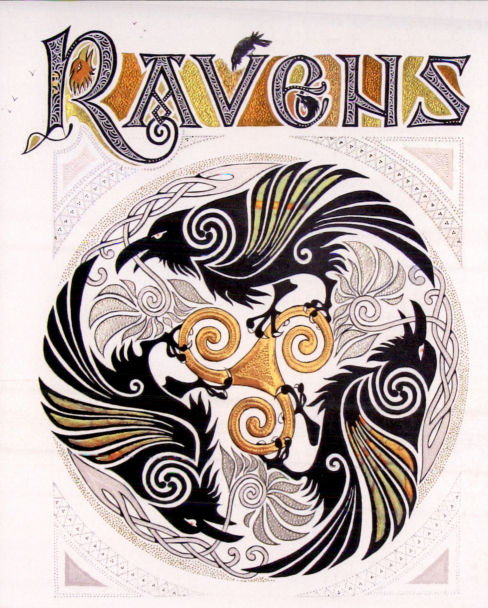

Ravens

This large piece has a central design that utilises different colours of gold leaf on PVA, with indented dots. The celtic display capitals at the top echo the theme and technique. The biblical verse at the bottom is written in half uncials (insular majuscule), a style sympathetic to the design which was inspired by historical Celtic manuscripts.

Calligraphic lettering

The following pages guide you through a number of calligraphic alphabets, giving you guidance on the basic stroke order of each letterform, the pen angles required to achieve their correct character, and illustrating common mistakes to avoid.

The letterstyles have been chosen to represent the major historical styles of the last two thousand years, including foundational hand which is a really useful style with which to start your calligraphic journey. It will give you a firm base on which to build your developing lettering skills.

The alphabets featured in this book are but a small selection to spark or increase your interest. My hope is that you will be sufficiently inspired to visit your local museums or libraries to see the wealth of amazing, inspirational examples of decorated manuscripts through the centuries.

Inspiration

A great way forward on your calligraphic or lettering pathway is to join a renowned lettering society, and to attend workshops and classes wherever possible. You might also visit the British Library in London, UK, to be inspired by the beauty of the illuminated manuscripts.

A brief history of calligraphy

The calligraphy in this book celebrates a number of historic styles, the earliest of which are imperial capitals that date back to Ancient Rome. During the decline of the Roman Empire, the uncial scripts associated with Christianity were emerging. These were at the height of their popularity during the fourth to eighth centuries AD following the fall of the empire. During the latter part of this period, the insular styles of the British Isles – the magnificent celtic display capitals and book hand of half uncials (also called insular majuscules) – were appearing in the elaborately decorated pages of many manuscripts. Notable examples of these scripts can be seen in the magnificent *Lindisfarne Gospels* and the *Book of Kells*, which date from the seventh and eighth centuries respectively.

The ninth and tenth centuries saw the appearance of embellished and decorated versals and later on, their close relatives, lombardic capitals. Carolingian or caroline minuscule, a rounded style on which foundational hand was later based, also became a widely used script throughout Europe during the ninth to thirteenth centuries. During this period the letters gradually narrowed, evolving into angular styles known as gothic or black letter. These styles were popular during the twelfth to fifteenth centuries, especially within beautifully illuminated and decorated manuscripts. They were followed by the humanist and italic styles of the sixteenth and seventeenth centuries.

The invention of printing saw a decline in calligraphic lettering until the advent of the Arts and Crafts movement in the nineteenth century. This led to fabulous new examples of lettering and decoration during the Victorian period and calligraphy became hugely popular once more. Today, it continues to flourish, with some of the finest practitioners expressing their creative freedom within the bounds of this wonderful discipline.

Opposite:

The Tower

A companion piece to Ravens (see page 15), this piece uses the same techniques and letter styles. Both were prepared as part of the inspirational Letters After Lindisfarne project, organised by the International Research Centre for Calligraphy.

Note the enlarged, gilded decorated capital H at the start of the central message – an effective and eye-catching traditional approach to illuminated lettering.

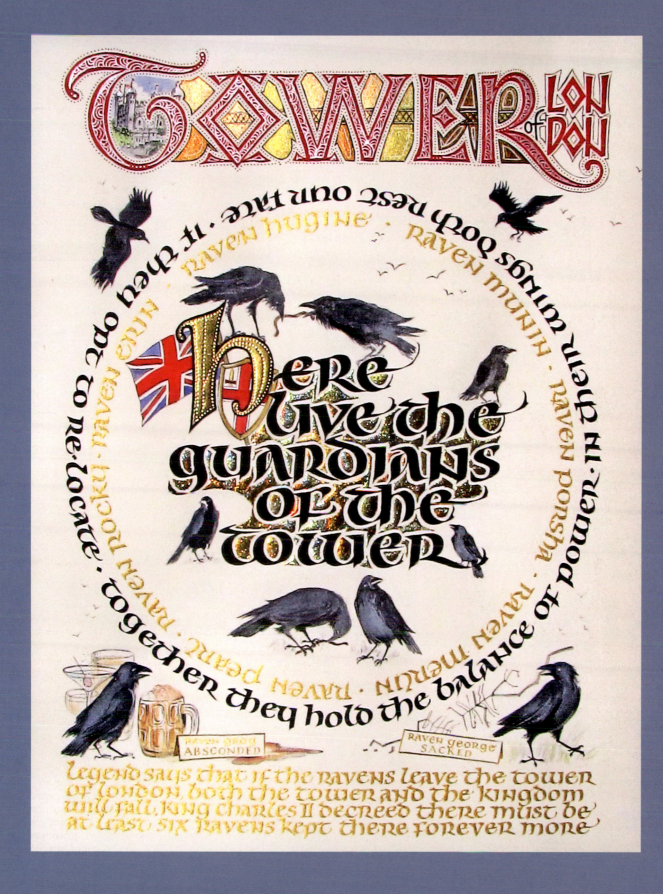

Basic techniques

Preparing a working puddle

Writing liquid needs to be mixed so it is thin enough to readily pass through the pen while remaining thick enough to cover with an even density.

If you are struggling to get gouache to flow, try adding a little more water with your brush. Add small amounts of water at a time to avoid mixing great lakes of over-diluted colour.

1 Squeeze a small amount of gouache or watercolour into a small palette well.

2 Using your mixing brush, add a little clean water and mix some of the fluid to the consistency of single cream. There is no need to mix the whole well to the creamy consistency. Just make sure you have sufficient to load your brush. This is your 'working puddle'.

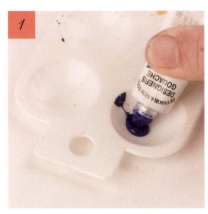

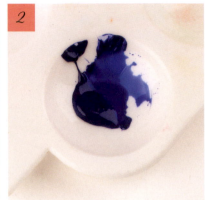

Holding the pen

For the best results, hold your pen firmly but comfortably at all times. Be aware of the need for sensitivity of pressure and try not to use a 'white knuckle' grip.

Loading your pen

Writing flow will be enhanced with a properly loaded pen. An over-filled pen can 'blob', while too little fluid causes too many interruptions.

Top-loading nibs are easiest to fill. The tip of bottom-loading reservoirs must physically touch the back of the nib or it will not hold the liquid. Position the reservoir tip just a tiny distance back from the nib edge.

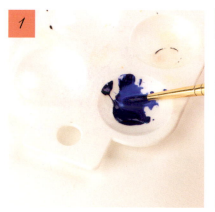

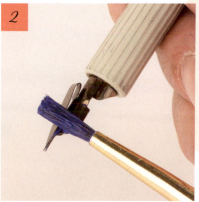

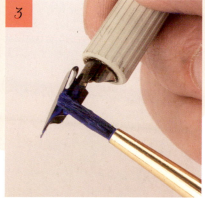

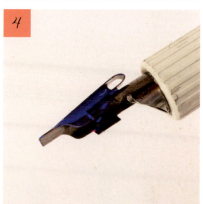

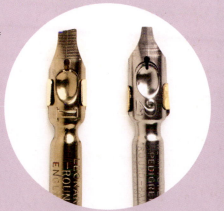

1 Load the brush with your prepared writing fluid.

2 Using a nib with a top-loading reservoir, hold the pen slightly on its side and touch the brush on the side of the nib.

3 Draw the brush in a downwards direction, allowing the liquid to gently dribble in and fill the reservoir.

4 Your pen is now well loaded and ready to write. Note that there is still a little space left at the top.

Left-handed calligraphy

If you are left-handed – don't despair. The biggest nuisance you will experience is that of pen angle: it can be a little more difficult for left-handers to comfortably hold a pen at the correct forty to forty-five degree angle for scripts such as italic.

Styles that use flatter pen angles, such as uncials, are well worth studying as starting scripts, but you will eventually want to tackle steeper-angled lettering. Fortunately, left-oblique nibs are available, which are designed especially for you to achieve this angle more readily. Another tip to try is slanting your paper down towards the right to help obtain the steeper pen angles.

A left-oblique calligraphic nib (left) next to a standard nib (right). The steeper angle makes the left-oblique nib more comfortable for left-handed calligraphers to use.

Calligraphy explained

The following pages explain some of the more technical aspects of calligraphy. Spending a little time to learn these will help you to practise and develop your skills so that you can reproduce the letterforms perfectly every time.

If you want to get stuck straight into decorating letters instead of learning the technical aspects of calligraphy, turn to pages 42–57, where you will find alphabets without directional arrows. These can be copied or traced following the instructions on page 132, and you can then begin to decorate them as you wish.

The x-height

An illustration like that shown to the right accompanies each calligraphic alphabet to show the height that letters should be drawn with your edged pen. The height of the blocks determine the x-height for the style you are using with that specific pen, so make the blocks with the same pen you will use for the lettering itself. Accuracy is vital: the blocks need to be accurately drawn, with your nib held at right angles to the writing lines, otherwise incorrect proportions will inevitably result.

The space between the two solid lines (the midline and the base line) is the all-important x-height and shows the depth of a basic minuscule letter, without an ascender (like an h) or a descender (as in a g). Above these lines, the blocks show the height of the ascender and below the x-height are the blocks to show depth of descenders.

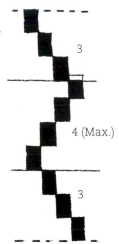

3

4 (Max.)

3

An example of the x-height illustrations that accompany each calligraphic alphabet. The numbers refer to the number of 'blocks' made with the pen nib. 'Max.' indicates that you should avoid going bigger, as it will cause the letter to lose its character.

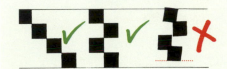

Nib width blocks

Either of the nib width block patterns shown on the left and centre above are acceptable, but to give accurate information on the x-height, they must be drawn tip to tip and not overlap in any way, as shown above right.

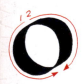 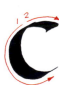 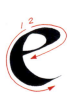 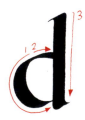 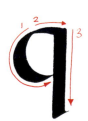

Stroke order, family groups and the important o

Each letter in the alphabets in this section has red arrows that indicate the direction of the pen stroke you should make to form the letter. These arrows are numbered, as shown above, to give you the order in which to make the strokes to form the letter correctly.

The o is an important letter in calligraphic alphabets as it gives information about the widths and proportions of all the other letters, governs shapes of the 'round' letters and is also used as a guide for inter-word spacing (see page 25). The o also gives information on the shapes of the arches on letters such as b, h, and m in many styles. For this reason, it is usually the first letter to practise, and the first shown in the calligraphic alphabets on the following pages.

The letters are presented in family groups. These are groups of similarly shaped letters which share stroke order, so practising one shape will bring you part way to learning the next letter in that group. This is illustrated above, with the c, e, d and q essentially being variations of the o. Within each script, most letters can be put into these family groups. However, every style tends to have at least one or two letters which are not related to any others in the script; these are shown individually.

A family group with the numbered stroke order. Note the similarities between the letters. This example is from foundational hand script, which can be found on pages 26–27.

Calligraphic pen angles

The angle at which the pen is held against the ruled line is important. Each calligraphic alphabet on the following pages is accompanied by an illustration that shows the angle at which the majority of strokes should be made.

The photographs below show the angle between the base line (dotted) and the nib (dashed). On the left is an n worked in foundational hand, with the nib held at thirty degrees from the horizontal. On the right is a t worked in italic script, with the nib held at forty-five degrees from the base line. Making the stroke at forty-five degrees results in a finer line. By increasing the angle, you have thinned the stroke. Note that the crossbar was made at a different angle, with the pen flattened to thirty degrees.

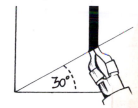

An example of the pen angle illustrations that accompany each calligraphic alphabet.

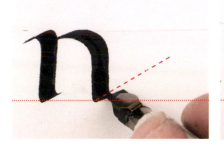
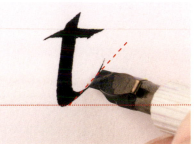

Changing the angle

As a general rule, the angle you start each stroke will be the angle you finish the stroke at (neuland is a notable exception). Some letterforms require you to work at more than one angle. These are marked with a * if you need to steepen the pen angle for the stroke, or a ° if you need to flatten the angle to zero degrees.

Steepening, or increasing the pen angle, narrows the stroke width. Flattening, or decreasing the pen angle, widens the stroke. Both these actions will be needed on several of the following pages, particularly for diagonal strokes which need to be thinned and for the mid strokes on Z, which need to be thickened.

The illustration above shows the importance of correct, appropriate pen for a particular style – the t below right has been drawn using the correct strokes but at the incorrect angle of forty-five degrees, resulting in a downstroke that is too thin, too thick on the base curve and a huge top and thick cross stroke. Correct pen angle really does matter.

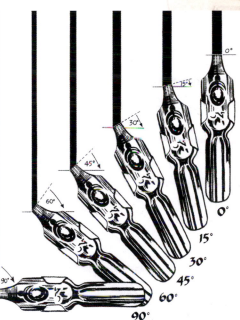

The angle at which the nib meets the paper affects the width of the drawn line, as illustrated here.

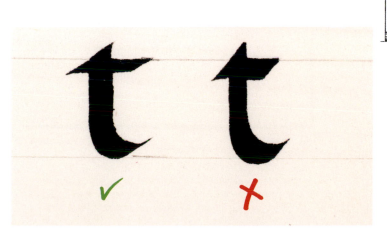

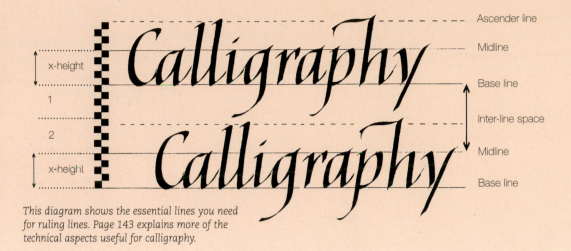

Ascender line

x-height

Midline

1

Base line

2

Inter-line space

Midline

x-height

Base line

This diagram shows the essential lines you need for ruling lines. Page 143 explains more of the technical aspects useful for calligraphy.

Ruling lines

Lines on which to write are a necessity, but they do not have to cause grief. You need to be aware of the heights of capitals, ascenders and descenders, but the more lines you draw, the greater the chance of inadvertent inaccuracies. Even if you do get everything correct, more lines means lots more rubbing out to do at the end!

Keep life simple and only rule those lines that are absolutely necessary: the base line and the midline, at the correct body height (x-height) for the style and nib size you are using. The illustration above shows these lines clearly.

To rule up, secure your paper to your board, then use a sharp 2H pencil to mark a thin strip of paper with the x-height and inter-line space and carefully transfer the marks down the left-hand side of your paper. You can then use your T-square to rule your parallel lines.

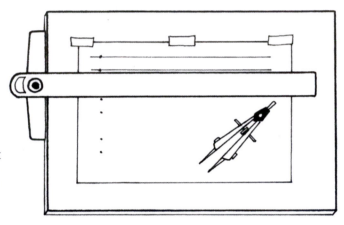

Ruling up

A drawing board and T-square makes ruling up quick and simple.

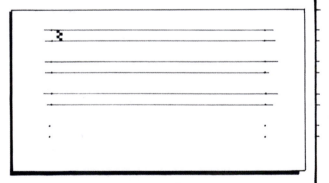

No T-square?

If you do not have a T-square, then use the same strip of paper to mark the right-hand side of the page, in order to ensure your guide lines are parallel and accurate. If using very small sizes, then use a pair of dividers to prick the same measurement down the depth of the page instead.

Tip

In most calligraphic styles, capital letters are usually drawn slightly shorter than ascenders; so they do not reach the ascender line.

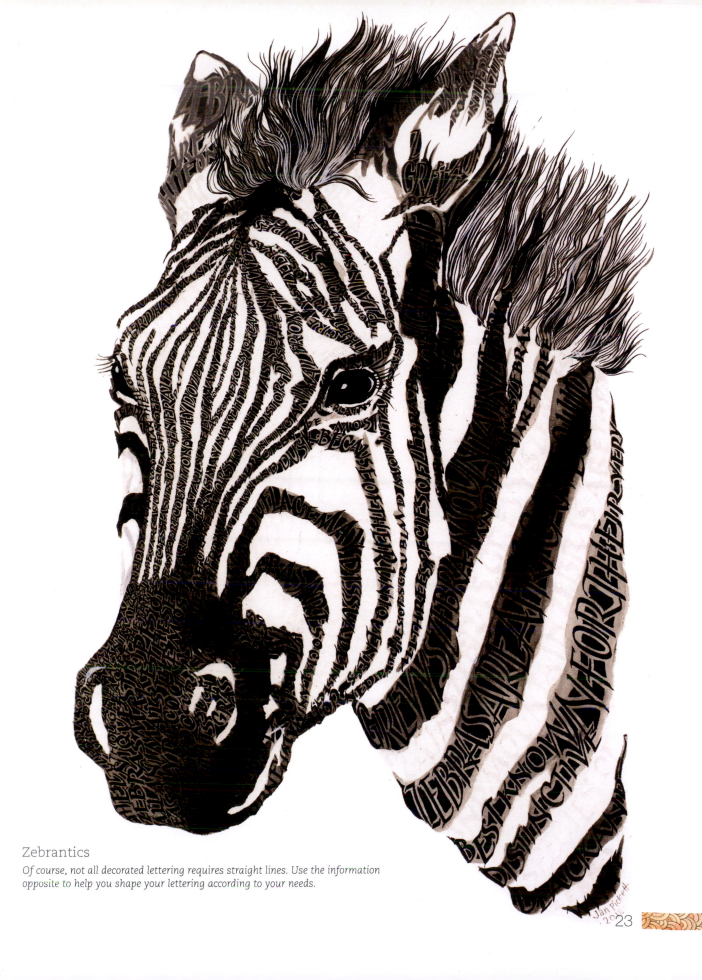

Zebrantics

Of course, not all decorated lettering requires straight lines. Use the information opposite to help you shape your lettering according to your needs.

23

Spacing

There are three kinds of spacing to consider when lettering: spacing between letters, between words, and between lines. Spacing of letters and words is vitally important and cannot be underestimated, as good, competent lettering can be ruined by uneven spacing.

Inter-letter spacing

Spacing between letters can not be easily measured, as letter shapes are different. The gap between letters needs to look balanced and even, and this will depend on the shapes of the individual letters concerned.

As a general rule of thumb, the most space should be left between two straight-sided letters, the least space between two circular shaped letters and the space between a circular and straight-sided letter should be somewhere in the middle.

Visualising 'corners' on curved letterforms can help you with inter-letter spacing.

Checking inter-letter space

A good way of checking your inter-letter spacing is even is to look at the word in groups of three, as shown below, in order to make judgements. Some letters have their own space and may need neighbours to be positioned closer to stop great 'holes' within a word, as seen with the T shown to the right.

EXHIBITION ✗

Filling the space

Imagine pouring a jug of water between any two letters. The same amount of water should fill the area between the letters, if they are correctly spaced. It will overflow if the same amount is poured between two straight-sided letters too closely aligned; or fill only halfway up between letters spaced too widely apart.

word space spacing
relates to the "o"...

for we

Inter-word spacing

Leave a space between words roughly equivalent to an 'o' shape of the letter style you are using (see above). Adjustments will probably be necessary for letters whose shapes naturally have a large open area, so a word ending with an small 'r' next to a word starting with a diagonal letter such as a v, y or w may need to be a little closer (see left).

Inter-line spacing

Generally speaking, leaving twice the x-height between each writing line will give sufficient space to avoid a clash between descenders tangling with ascenders on the line below, as shown to the right. The space can of course be varied, dependent on the letter style being used and on the specific needs of the text. If you were using uncials as your letterstyle, for example, then one and a half times the x-height would be sufficient for the inter-line spacing, due to their short ascenders and descenders. Start with inter-line spacing at twice the x-height of the lettering, and adjust as necessary.

Longer lines look less cramped with more space between lines. Conversely, less space may be left between short lines of text if required.

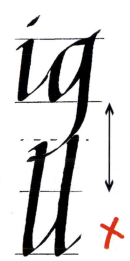

Insufficient inter-line space

The inter-line space here is only one-and-a-half times the x-height, which results in the descenders clashing with the ascenders.

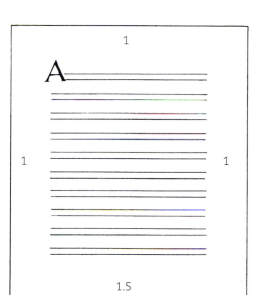

Margins

In addition to the spacing of letters and words, there should be enough space on your paper. Any piece of lettering needs clear space around it to do it justice, so do give thought to your margins. A good starting point is shown to the left, where a similar amount of space is allowed for the top and sides, with half as much space again at the base of the writing (the last line of text). Calligraphy needs room to breathe.

There will always need to be adjustments, which will depend on the content – decorations in the margin, or enlarged capitals will alter the space, for example. Details such as these must be taken into consideration and a little more space added to allow for them.

Tip

As an *aide-mémoire*, remember: 'bottoms are bigger!'

Foundational hand

This elegant hand was developed by Edward Johnston (1872–1944), who is considered to be the father of modern calligraphy. It is based on examples of carolingian script used in manuscripts of the ninth and tenth centuries, in particular the examples from the tenth century *Ramsey Psalter* on view today in the British Library in London. Along with the italic hand (see pages 36–39), this is among the most useful styles for today's calligraphers, for both formal and informal documents.

The modern version differs slightly from Johnston's original, but maintains the beauty and elegance of his script, which is written with a thirty-degree pen angle and has rounded, upright letterforms. Designed as a teaching hand, foundational is a good style with which to begin your calligraphic journey. It does not have its own capital alphabet, but pen-drawn roman capitals (shown overleaf) are ideal to be used with this hand.

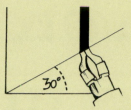

Pen angle

The pen is generally held at thirty degrees from horizontal for this script. The * symbol means you need to steepen the pen angle for the stroke, and a ° symbol means you need to flatten the angle to zero degrees.

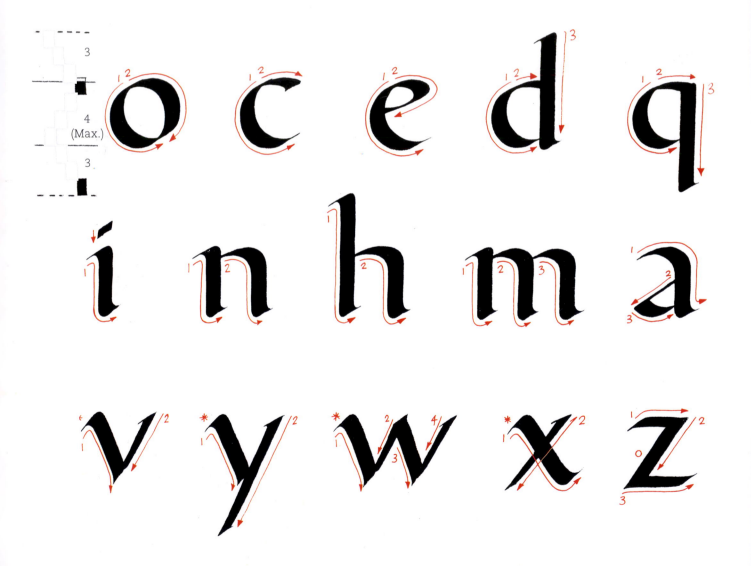

npdvo acdeghnstvz

Related shapes

The o in this style is circular. It governs not only the shapes and arches of related letters, but also the width of most of the whole alphabet, with the exception of i, j, m and w.

Common mistakes

a The left-hand rounded stroke should echo the 'o' shape.

c The top stroke is too hooked and should be flatter.

d As with the c, the top of the curve needs to be flatter.

e The diagonal stroke is far too steep and should finish almost horizontally.

g The top circular bowl needs to be smaller, not sitting on the base line. The descender needs to be an oval shape wider than the circular shape above.

h The top serif is not the correct shape. In addition, the arch is tight and starts too low down.

n The arch should be similar to the top of the 'o', starting closer to the midline.

s Top and bottom strokes should be flatter and less hooked.

t The pen angle used is too steep.

v Both strokes are too curved.

z The pen angle has not been changed to zero degrees for the diagonal stroke.

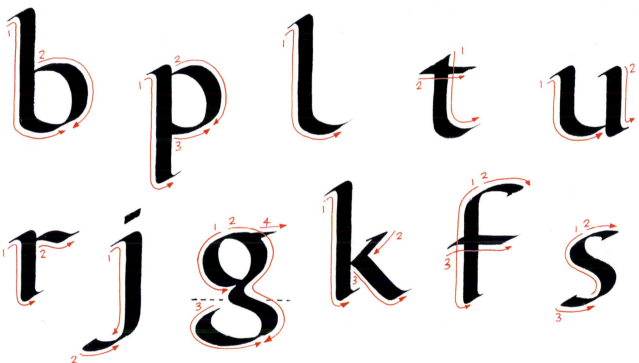

foundational hand numerals and punctuation

Roman capitals

Pen-drawn roman capitals are probably the most important in calligraphic history as they are based on the beautiful, classical imperial capitals used in Rome during the first century AD. Many superb examples of these sculpted letters can still be seen in Rome today, particularly on Trajan's Column. Their beauty and elegant proportions have stood the test of time and pen-drawn roman capitals should reflect this. The illustration shows the structure of these letters within their family groups (see page 20), to help you achieve the true proportions when drawing them with an edged pen. Pen-drawn roman capitals can be used separately or combined with the foundational hand on pages 26–27, which does not have its own capital form.

Roman capitals have an x-height of six nib widths, but the height can be varied according to requirements of the text. Straight strokes are vertically aligned with no forward lean and the curved letters are full and rounded, based on the circular o.

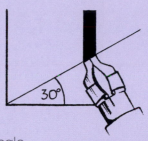

Pen angle
With the exception of certain strokes on M, N and Z, it is important to maintain an angle of thirty degrees for all letters to create balance and achieve elegance.

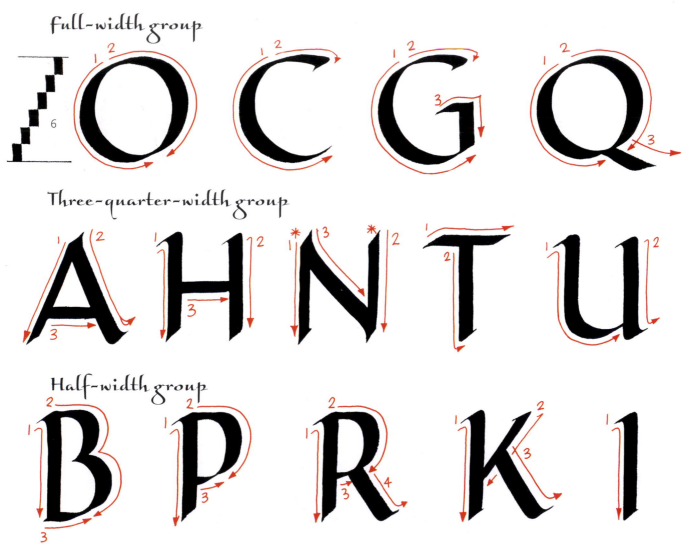

full-width group

Three-quarter-width group

Half-width group

Roman capital width groups

The majority of letters in this script come in one of three width groups. The full-width group are circular and fit snugly within a square, while the three-quarter-width group and the half-width group fill only part, as shown above. The few extra-wide letters do not fit within a square.

OABM

Full width. *Three-quarter width.* *Half width.* *Extra wide.*

ADEJKMNRS

Common mistakes

A Too narrow at the base, the crossbar is too high and the curve on the base of the right-hand stroke is saggy.

D This example is too narrow. In addition, the top is not flat.

E The mid stroke should be the same width as the top stroke.

J No top on J; historically it was related not to T, but to I.

K The lower leg should be straight.

M The outer legs are too splayed in this example. It might help to think of the correct form as looking like a V on crutches!

N Here, the vertical strokes are too thick.

R The top should be flat, the bowl shorter and the final stroke straight.

S The top and bottom strokes are too hooked – these should be much flatter.

Extra-wide group

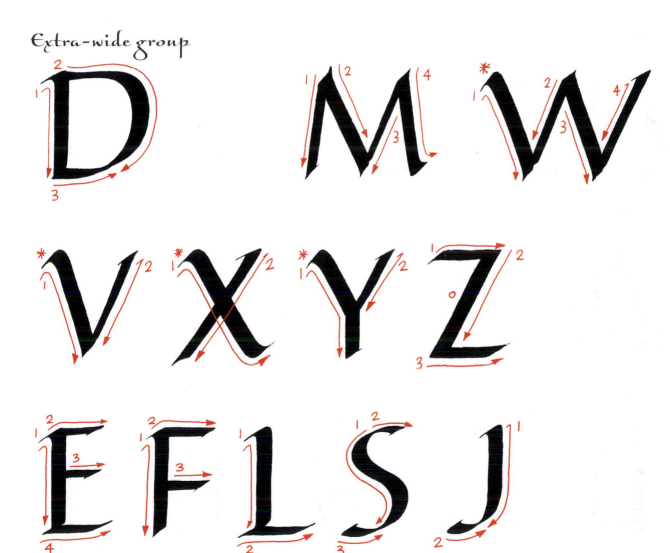

29

Modern uncials

Producing delightfully chunky letters, pen-drawn uncials give opportunities to decorate the surfaces of the drawn letter, as well as offering liberal space within and around the letterforms for additional creativity. The uncial letterforms illustrated here are a contemporary version of this very early script, which maintains the dignity and beauty of this historic style.

Uncial hand has a long history that dates back to the fourth century AD and the fall of the Roman empire. Associated with early Christianity, the style is very rounded, with short ascenders and descenders, and to modern eyes appears to be a curious mix of capitals and minuscules. This is because the script evolved before minuscules became separate from their corresponding capital forms. The term 'uncial' is believed to derive from the Latin for 'inch', which may have been the size that the letters were drawn when the style first became popular; though it was only comparatively recently, in the nineteenth century, that the style started to become referred to as such.

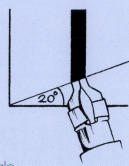

Pen angle

These modern uncial letterforms can be drawn with a pen angle between fifteen to a maximum of twenty degrees, with the usual steepening of the pen angle for entry strokes to the diagonal letters and a flattened pen angle for the mid stroke of z.

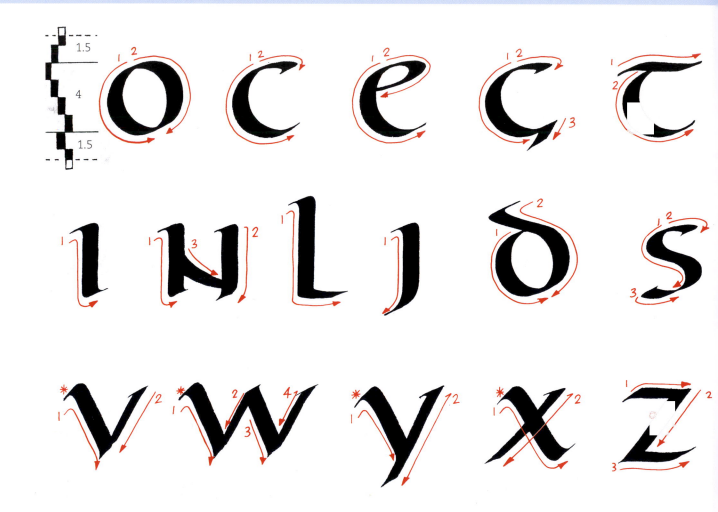

Related shapes

The uncial o is full and wide, and based on a circle. As with foundational hand, all the round letters follow a similar structure, as shown above.

The o also governs the widths of all the other letters, with the exceptions of i, j, m and w. While wider, the m still follows the appropriate parts of the o shape to look balanced.

Common mistakes

a The letter is too narrow, and the bowl of the letter too rounded and large.

d The ascender should be much more angled and drawn further to the left.

g The descender here is overlong and should travel back to the left, rather than straight down.

m This example is uneven, with unbalanced arches. It should also be more rounded.

n The mid stroke needs to slope down more, while the right-hand stroke is too long and hooked. Drawn incorrectly, an uncial n can look like a capital H to modern eyes.

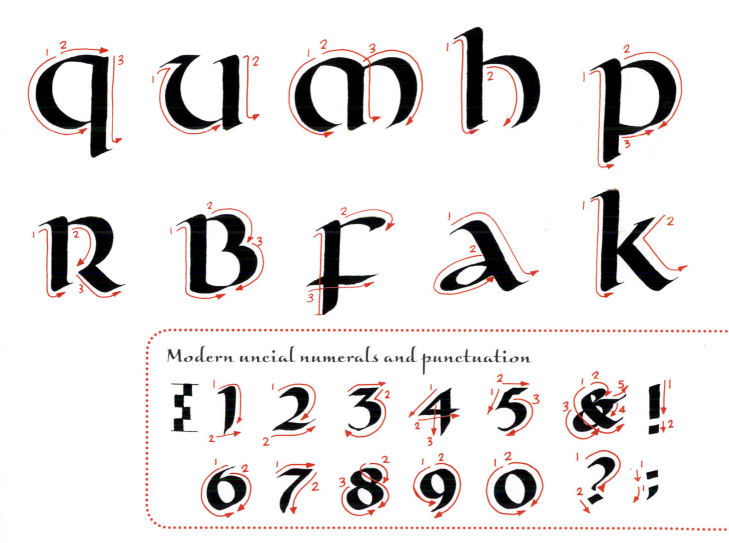

Modern uncial numerals and punctuation

Gothic minuscules

Gothic is a generic term for the various narrow, angular and decorative styles that originated during the early Middle Ages and developed from the open, rounded shapes seen in earlier times. The growing demand for written works in the thirteenth and fourteenth centuries, along with the hugely expensive price of vellum (the calfskin fabric on which the letters were written) led to an attempt to cram more and more onto the page, which led to the narrowing of letters and the emergence of this tightly-packed script.

The space within and between the minuscules is similar to the width of the vertical strokes. This creates a densely-filled black appearance, giving rise to the alternative names of black letter and textura. The example script here is based on textura quadrata, the name referring to the diamond-shaped 'feet' on the letter endings. Gothic is not often used in the twenty-first century and is waiting to makes its comeback!

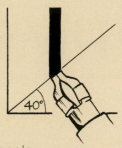

Pen angle
The pen angle varies between forty and forty-five degrees.

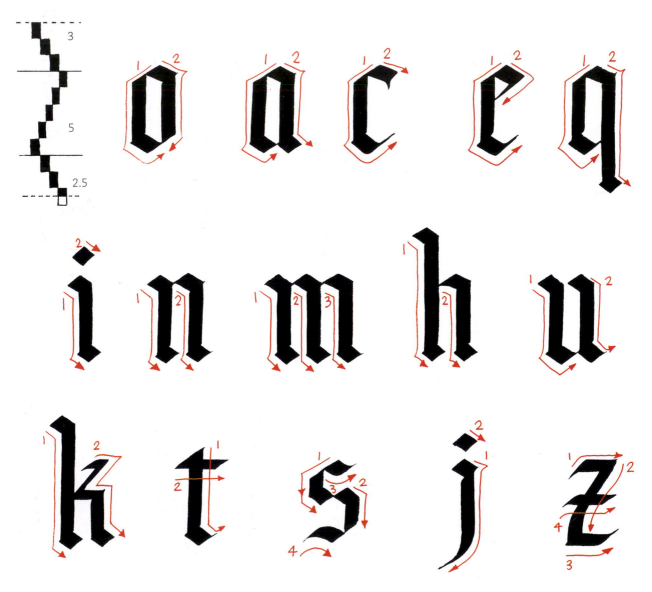

32

oksyo imadgs

Related shapes

The gothic o is narrow, with the counter space being a similar width to the strokes of the letter. As illustrated, the o governs the arch shapes and all letter widths, with the exceptions of i, j, l, m and w.

Common mistakes

i The top of the stroke is missing the distinctive diamond shape.

m Too widely spaced. Aim for equal amounts of black and white space.

a As with the m, the strokes should be closer together.

d The ascender is rounded instead of angled and has an extraneous 'foot'.

g The descender is an incorrect shape.

s The mid-strokes should only touch tip to tip. The bottom stroke is also an incorrect shape.

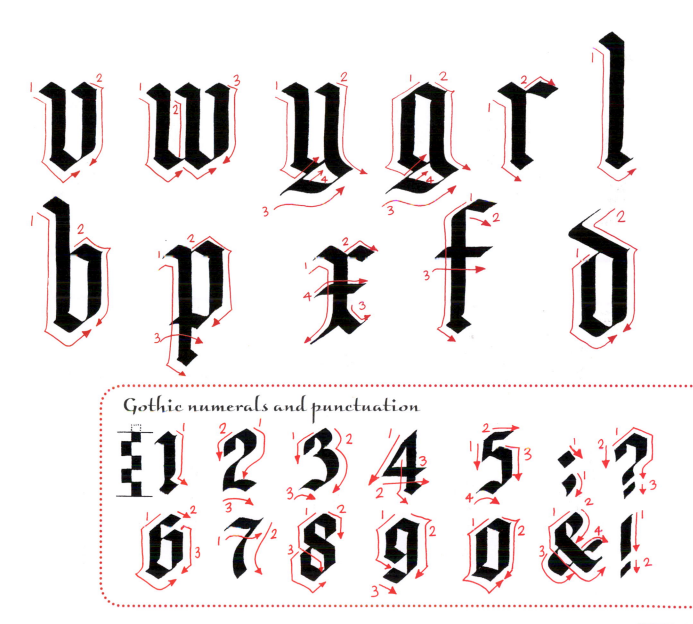

Gothic numerals and punctuation

Gothic capitals

Gothic capitals are many and varied, with no two historical manuscripts being exactly alike. They are delightfully decorative letterforms. The mood and character of these letters alter dramatically when their colour is changed from the usual black. As a result, it is very rewarding to experiment with your colour palette.

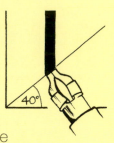

Pen angle

The pen angle varies between forty and forty-five degrees. A pen angle of ninety degrees is used for the added vertical hairlines and for the additional 'beak' decorations to the left of some of the letterforms.

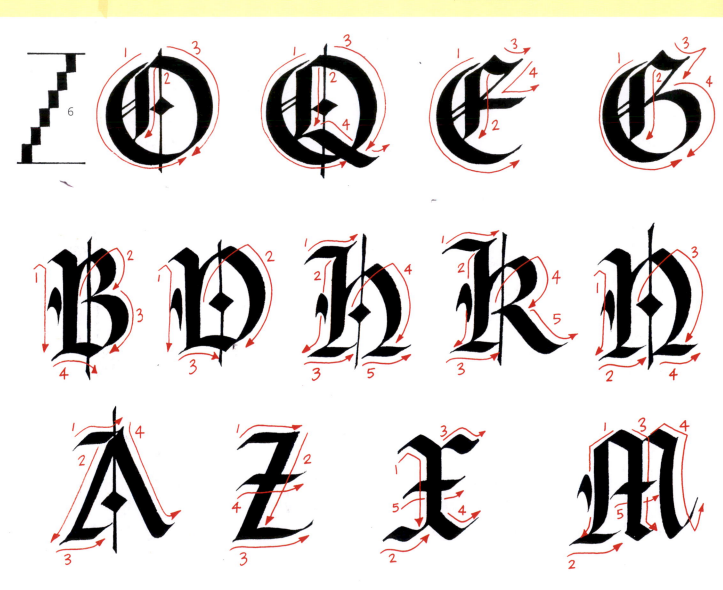

PLEASE AVOID ❖ ILLEGIBILITY ❖

Common mistakes

Avoid the temptation to use all capitals together, as they will become virtually illegible *en masse*.
Instead, combine these capitals with the minuscule letters on the previous pages.

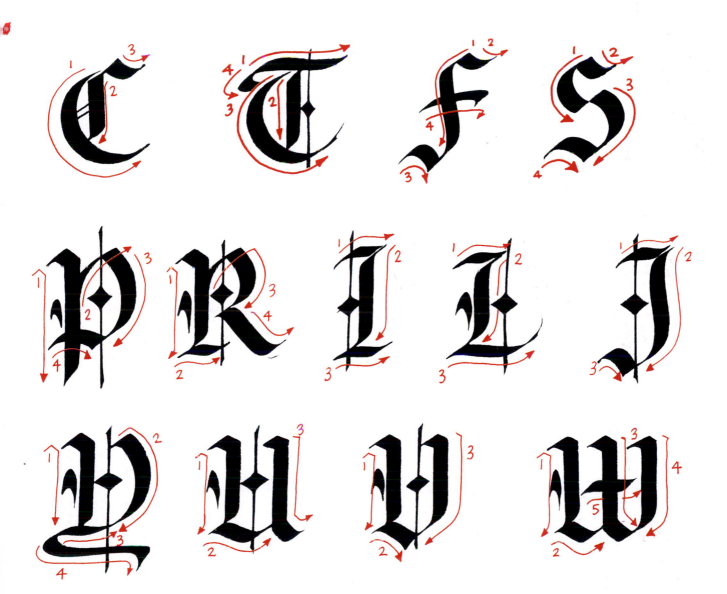

Italic minuscule

Formal italic is a lively, flowing letterstyle combining springing or branching arches with a slight forward slope of between five and ten degrees. The style originated in Italy and was favoured by the Papal chancery in the fifteenth century, where it was known as chancery cursive. The basic principles of these letters have remained essentially the same for five centuries.

Italic enjoys many variants, with elegant flourishes, but it is vital to be able to produce a good basic script before attempting these. As always, it is important to know the rules before 'bending' them. This flowing script has fewer pen lifts than other styles and can therefore be produced moro rapidly.

A defining characteristic of Italic lettering is the springing arch. It requires a 'pushing upwards' movement of the pen and it is a good idea to practise these shapes as it feels an unusual direction when using an edged pen.

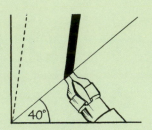

Pen angle

The majority of italic letters are the same width and are written with the pen at an angle of forty to forty-five degrees. The forward slope of the letters is between five and ten degrees, as indicated by the dotted line.

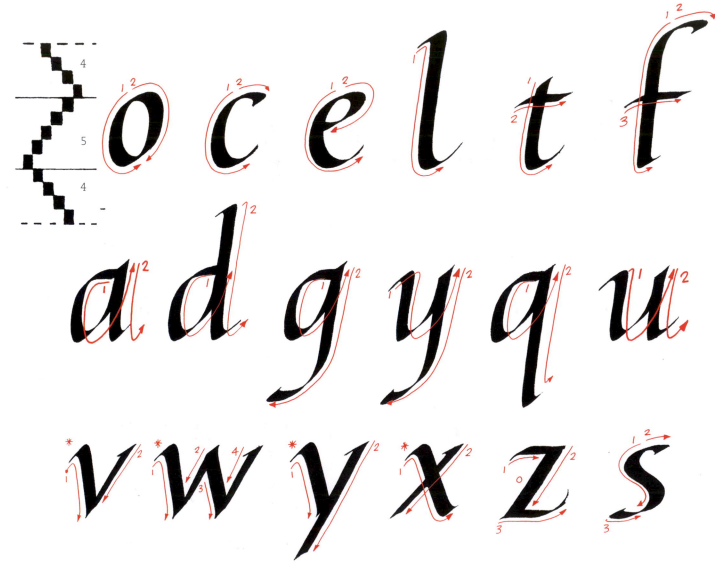

a n v o

Oval shapes

The italic letter o is oval in shape and, as with most of the alphabets in the book, governs the width of the other letters in the alphabet, with the exception of i, j, m and w. Letters c and e closely relate to the o, while the base shapes of l and t are similar to the base of the c. The letters are normally drawn at either four or five nib widths for the body height (x-height).

n a

Over-arm shape. *Under-arm stroke.*

Springing arches

The over-arm shapes (used in b, h, k, l, m, n, p, r) form the arches that 'spring' from the base, branching out halfway between the base line and midline to join the two parallel sides of the letter. The under-arm strokes (in a, d, g, q, r, u, y) are a similar but reversed shape, that joins the two sides of the letter halfway up the stem. Both over-arm and under-arm strokes must travel from the base line to the midline without stopping in order to create the italic character.

h k b

Related shapes

The shape in red on the left, above, is common to the letters h, k and b.

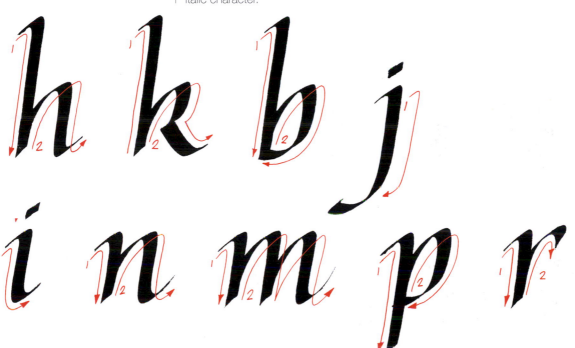

Italic numerals

1 2 3 4 5
6 7 8 9 0

Italic capitals

This script emerged during the Italian Renaissance in the early fifteenth century. The italic hand is probably the most useful of all scripts for today's lettering artist as it is so versatile, being suitable for both formal uses and the informal – where decorative flourishes can be used freely.

As with the minuscules, italic capitals are sloped and compressed. Straight-sided letters of italic capitals have a forward lean of between five and eight degrees from vertical. The letters follow the same width groups as for roman capitals, but due to their compressed structure, the differences are not nearly as noticeable.

Italic capitals look elegant drawn at six nib widths, as shown on these pages, but height and width can be varied readily. Used alone, italic capitals could be short and chunky at just four nib widths high. In conjunction with minuscules with an x-height of five nib widths, capitals could be drawn seven nib widths in height.

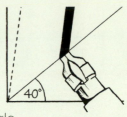

Pen angle

The majority of letters are written with a pen angle between forty and forty-five degrees.

The diagonal letters (V, W, X and Y) need the first stroke drawn with a steeper pen angle in order to decrease the thickness slightly, while the diagonal stroke of the Z should be drawn with a pen angle of zero degrees to make it fatter. This helps to achieve a contrast between the thick and thin strokes.

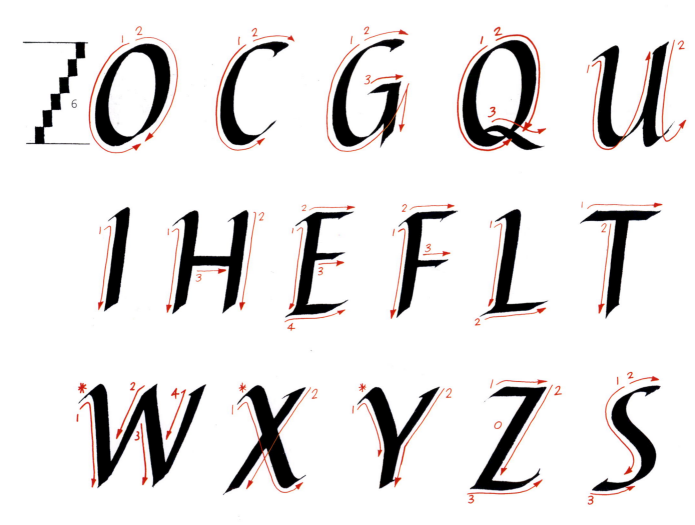

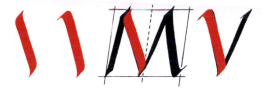

Diagonal strokes

The strokes highlighted above are similar diagonal strokes, but there are subtle differences in shape. The first is used for strokes like the second strokes of an M and N. Compare this with the second, used for the initial strokes of a V and a W.

Width variations

It is important that width variations should remain constant within a size and always relate to the letter O as shown above.

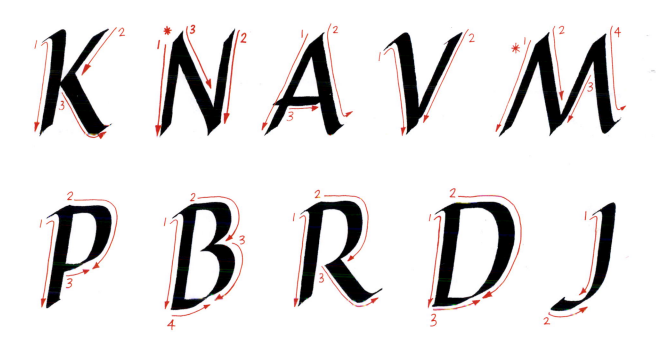

Neuland

Neuland is a wonderfully quirky style. Designed in 1923 by Rudolf Koch (1876–1934) for the Klingspor Type Foundry, and based on his own handwriting, the original versions were hand cut into punches. This resulted in each type size being slightly different and therefore unique. Neuland's capital-only design, of strong angular features with slightly concave shapes on some of the heavy vertical strokes, became enormously popular as an advertising typeface. Type styles that draw inspiration from neuland are still used for several well known brands today, notably a coffee company and a film about a park full of dinosaurs!

Neuland differs from the other letterforms in this book, as it is composed entirely of thick strokes as opposed to the more conventional combination of thick and thin widths. To achieve this even weighting, it is drawn with varying pen angles, mainly of zero and ninety degrees from the base line. As a result, unlike the other calligraphic alphabets in this book, the letter groups do not start with the O as they are all so individual.

Neuland letterforms can be readily adapted to host a wealth of creative ideas, from stacking blocks of text to single initials with a large overall area that can be gilded, shadowed or support any other form of decoration.

Pen angle

Neuland is not written at a set angle – see 'Changing the angle' on the opposite page.

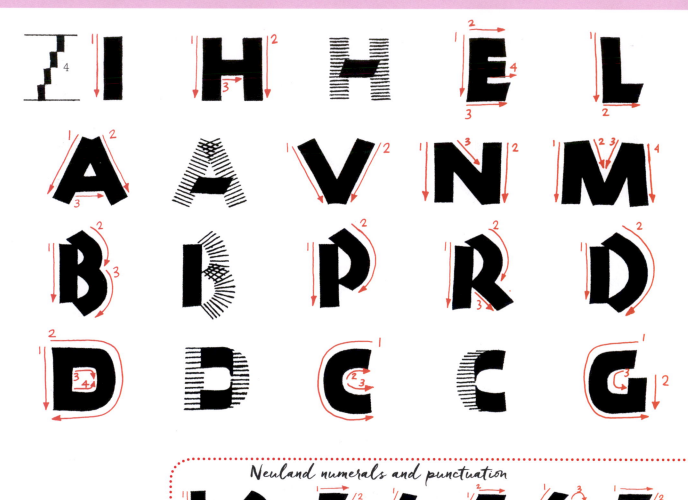

Neuland numerals and punctuation

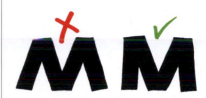

Changing the angle

The solid lines in the alphabet below show strokes that are made in straight lines at a single angle, while the dashed lines represent strokes during which the nib must change angle to create a curve or corner.

The step-by-step process above shows how a C is drawn to illustrate a curving stroke. Note how the angle at which the nib touches the page changes through the stroke.

Common mistakes

Not keeping the stroke a constant width is the most obvious mistake to make. Pay attention to changing the angle for a consistent stroke thickness.

As with roman capitals (see pages 28–29), the M is not an upside down W, with splayed legs. Instead, draw it with straighter legs, just off vertical.

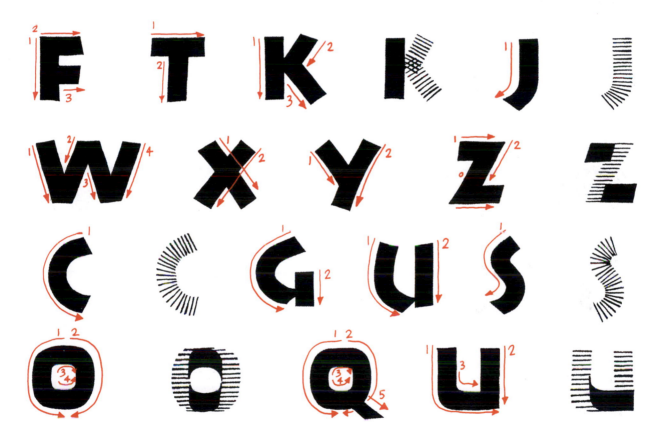

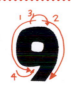

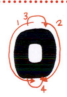

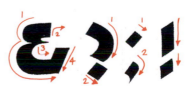

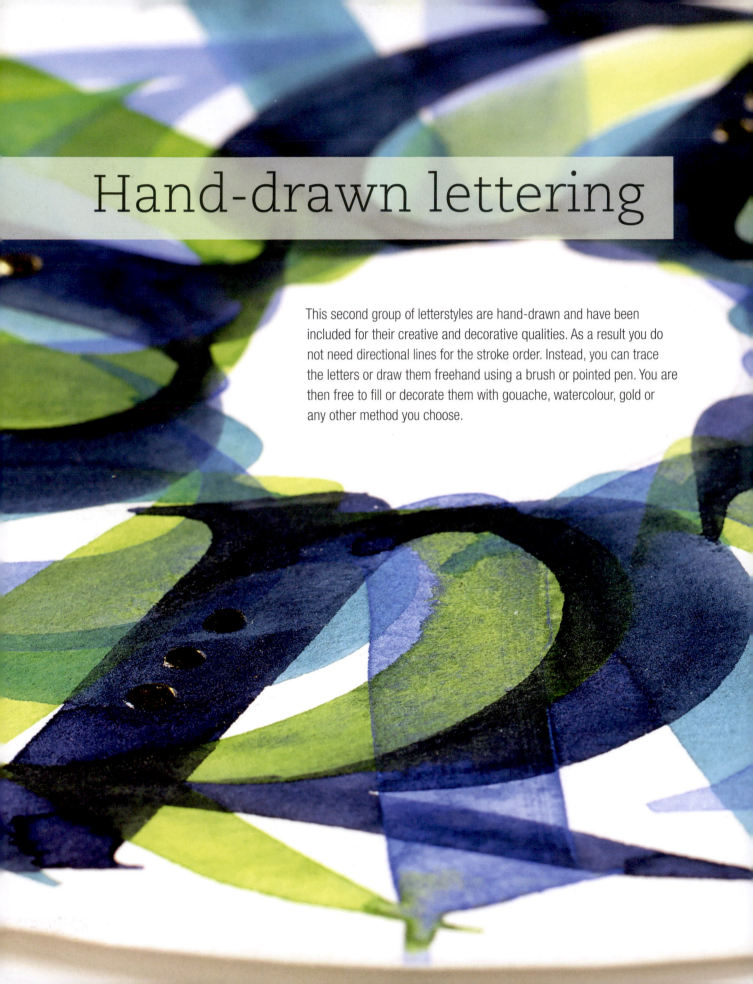

Hand-drawn lettering

This second group of letterstyles are hand-drawn and have been included for their creative and decorative qualities. As a result you do not need directional lines for the stroke order. Instead, you can trace the letters or draw them freehand using a brush or pointed pen. You are then free to fill or decorate them with gouache, watercolour, gold or any other method you choose.

Compound lettering

Some lettering styles require compound strokes. This simply means that more than one pen movement is needed to create certain parts of the letterform. This makes them more complex to write. They can be enjoyed at a more advanced calligraphic stage, but for the purposes of this book, I suggest you simply copy or trace the letterforms.

Versals and lombardic capitals are historically and traditionally calligraphic and good examples of this sort of compound lettering. Their sheer beauty and decorative potential means they could not possibly be left out, so despite their relative complexity, they are included in this section of the book. In addition to the compound lettering styles, the following part of the book includes alphabets that have no historical precedent – they are simply beautiful decorative lettering to be used as you wish in your designs.

A B C D E

K L M N

S T U V

Versals

These elegant, gently waisted capital letterforms can be created using compound strokes of an edged pen (this is necessary to create the bolder parts of the letter) or, as illustrated here, they can be hand-drawn and painted. Their underlying structure and proportions are based on the carved roman imperial capitals from the first century AD, many examples of which still remain in Rome today.

Highly popular during the ninth and tenth centuries, the finest examples of versals are seen in traditionally-decorated and illuminated manuscripts, notably the *Ramsey Psalter*, where they mark the beginnings of verses and chapters. Today, contemporary versals are often used for whole texts.

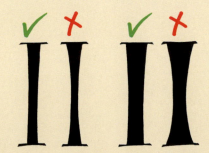

Common mistakes

Avoid making your letters too heavily waisted. This will spoil the elegance of the letters, which should have a subtle taper and flare.

F G H I J

O P Q R

W X Y Z

Decorative ideas

Versals are extremely adaptable, lightweight letters and can be compressed, expanded, made bolder and have serifs added. For decorative purposes, they offer unlimited opportunities within the visual world.

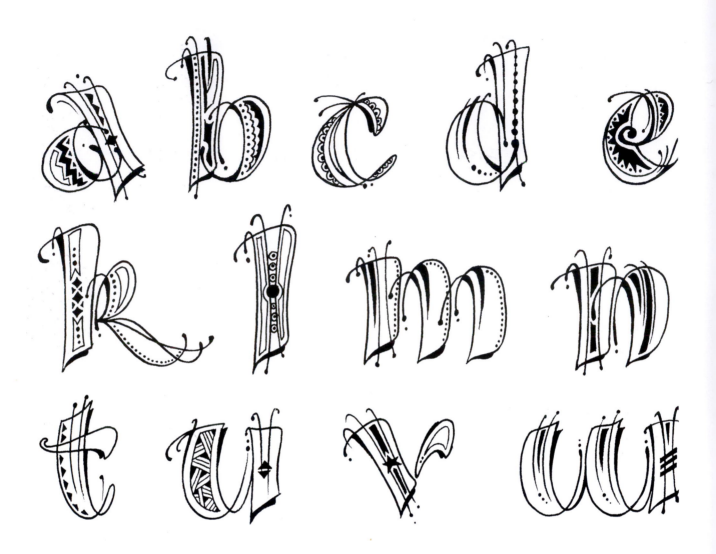

Freestyle minuscule

These freely drawn letters are simply 'fun' alphabetic shapes for decorative possibilities. They are very loosely based on foundational hand (see pages 26–27) in that they have the same bold and lightweight areas within their construction.

The thick and thin parts follow a similar pattern within the entire alphabet so that they appear balanced, with plenty of open areas for you to be inventive. Within the individual letters are various suggestions of pattern, which could be altered, added to or simply coloured… so enjoy!

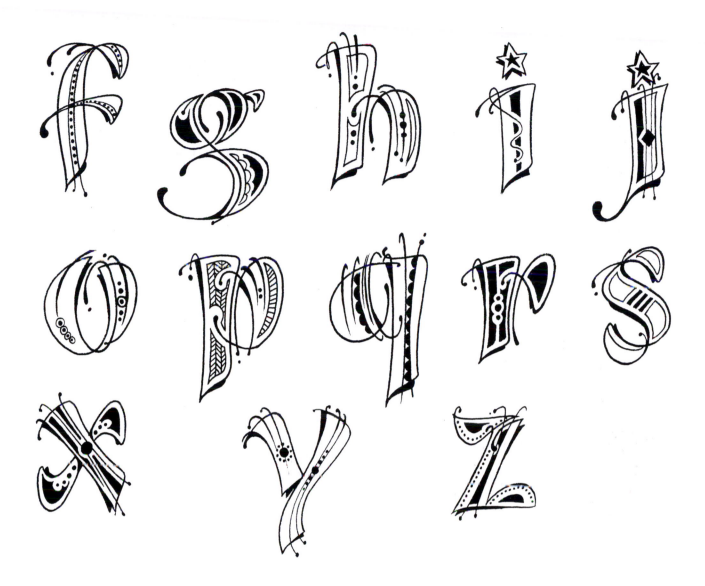

Decorative ideas

The alphabet above shows a hugo selection of varied designs and suggestions for decoration.
Mix and match the different decorative styles to open up an almost infinite variety of ways to decorate the letterforms. There are even more patterns and suggestions on pages 136–137.

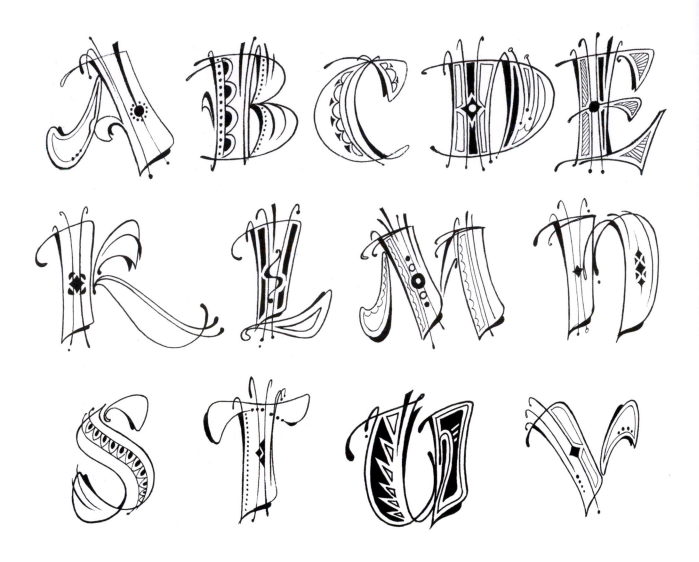

Freestyle capitals

As with the freestyle minuscules on the preceding pages, these freely drawn related capitals are simply fun alphabetic shapes for decorative possibilities. As before, they are loosely based on roman capitals (see pages 28–29) in that they have similar bold and lightweight areas within their construction.

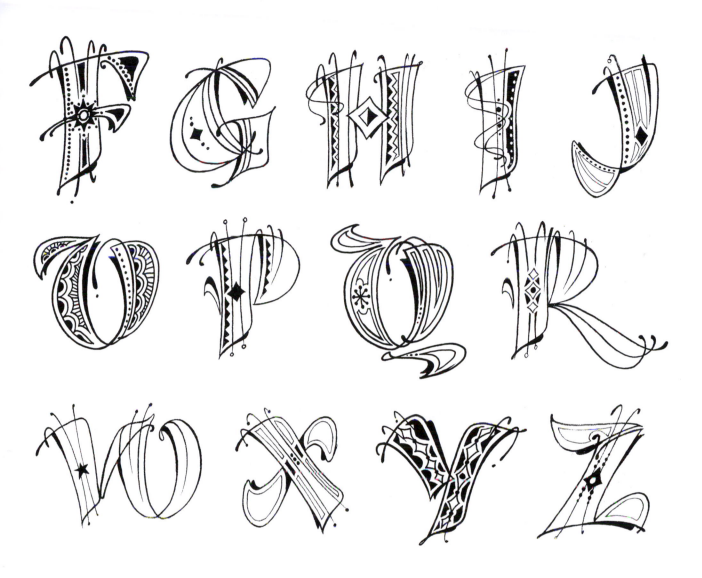

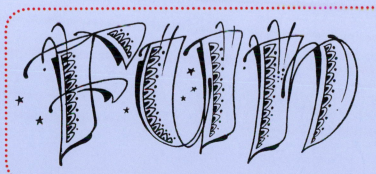

Decorative ideas

The basic outlines of these freestyle capital letters give ample space for play. Experiment with different decorative flourishes in, on and around the letters using the examples here and on pages 136–142.

As the example here shows, using similar decoration on all the letters in a word can look very striking.

Celtic display capitals

Beautifully decorated manuscripts of the seventh to ninth centuries, especially the *Lindisfarne Gospels* and the *Book of Kells*, show many examples of these capitals. Notably, they appear on the *incipit* (the opening page) of each of the Gospels. The first words are enlarged and greatly elaborated with patterns and adorned with delightful additions of animal heads, human heads, intricate Celtic interlacing and rubrication – the patterning with traditional red dots.

There are many variations of each letter design to be seen. Depending on which manuscript you look at, the letters show elements of several styles – including runic alphabet and half uncials – which have influenced the scribe.

CC CO CO EE

II K L M M

P q q RR R

M W X Y Z

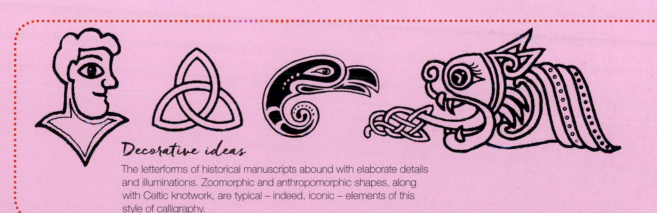

Decorative ideas

The letterforms of historical manuscripts abound with elaborate details and illuminations. Zoomorphic and anthropomorphic shapes, along with Celtic knotwork, are typical – indeed, iconic – elements of this style of calligraphy.

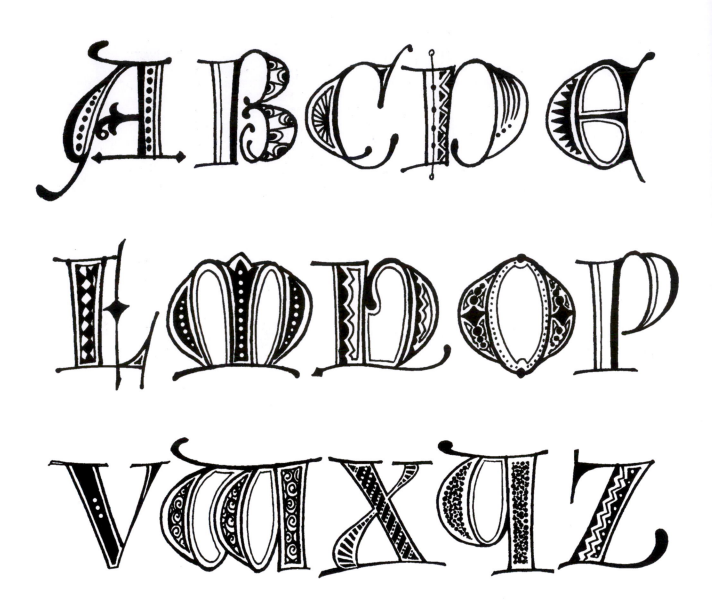

Lombardic capitals

This highly decorated style is a close relative of versals (see pages 44–45), with lombardic capitals usually appearing much bolder and adorned with decorative hairlines and long curving serifs. As with versals, lombardic capitals are compound letters, meaning they can not be created with single strokes of an edged pen. Fortunately, drawing them allows for much creative freedom, especially with their elongated serifs.

Historical lombardic capitals provide a constant delight to the reader. The style was frequently used in twelfth-century English bibles, with many delightful variations in the designs. Indeed, the decoration was limited only by the imagination of the scribe. *The Winchester Bible* is a notable example of this mediaeval art, being the largest and arguably finest surviving example of these bibles. Lombardic capitals were often used in combination with the gothic style of lettering and were popular until the sixteenth century.

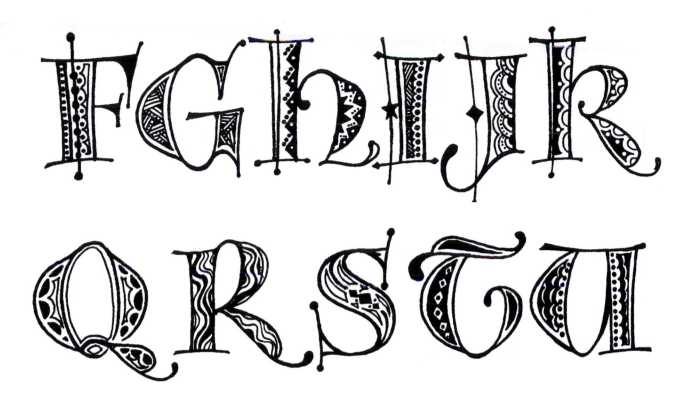

FGHIJKR
QRSTU

ABC·ABC·ABC

Decorative ideas

Lombardic capital letterforms have beautiful shapes, and are as pleasing to look at in solid colour as they are in the highly decorated versions shown in the main alphabet above.

Boxed in

This style is based on neuland forms within boxes. Where the letterform 'overflows' the shape, small areas of the outline are removed, leaving just sufficient information for the profile of the letter to remain clear.

These can be particularly useful as templates for embossing as well as other forms of decorative application.

Decorative ideas

The boxed in letterforms can be left in outline (as in the main example alphabet above), but they also look great with areas filled in with solid colour, or covered in dotted and patterned areas as above.

These bold, strong letters work particularly well with the acetate template and pastel technique on page 109.

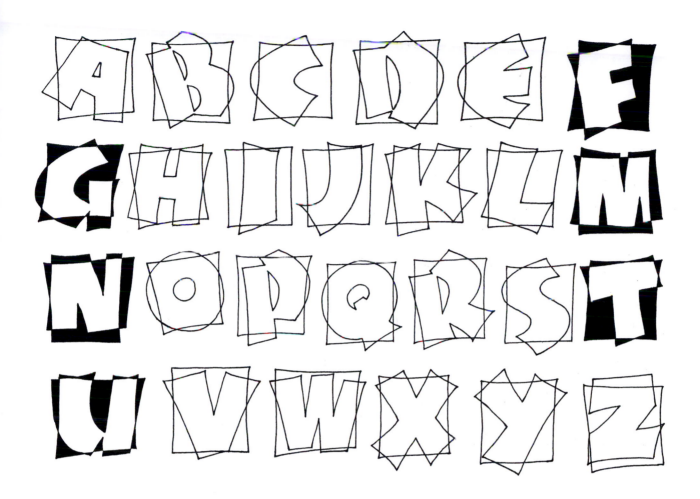

Letterbox letters

Perfect for playing, these letters invite both colour or black and white infilling – or patterns, of course. They are easily prepared and mounted for an attractive birthday card.

Decorative ideas

In addition to filling in areas that lie outside the letter shape, as shown in some of the examples above, you can fill them in – as shown in the numerals here.

ABCDEFG
HIJKLMN
OPQRST
UVWXYZ

Outline serif capitals

Serifs are the small additions at the top and base of some letterforms. Not simply decorative, serifs can serve to help your eye move easily from letter to letter throughout a text. Many books use letterstyles with serifs because they can make the writing both easier and more pleasing to read (as in the heading above).

This alphabet is loosely based on versals and has similar proportions to Roman capitals.

Decorative ideas

The letters above show examples of various letter styles with serifs. Whichever you choose, the basic letterforms themselves offer space to decorate imaginatively.

ABCDEFG
HIJKLMN
OPQRST
UVWXYZ

Outline sans serif capitals

As described opposite, serif styles dominate the world of the printed word, but websites tend to use 'sans serif' – French for 'without serifs' – styles, as they offer increased clarity on the screen.

This sans serif alphabet is a simple outline capital letterform with plenty of space available for decoration. These are the perfect letters to house 'stained glass' effects.

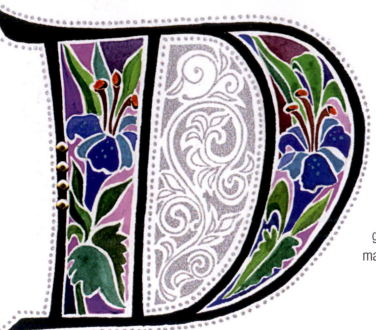

Decorating your letters

Where to start? The possibilities and potential for decorating letters are enormous and experimenting will give huge pleasure, but broadly speaking, there are three main categories, explained below.

Decoration within letters

The counter space – the area contained within the body shape of a letter – offers opportunities for many forms of decoration. These can be filled using stippling, pressure and release, gel pens, gold and metallic covering, perhaps even dots of gilding – all mouthwatering possibilities that are explained on the following pages. Any of these treatments can also be applied on top of dried watercolour as well.

Some letters have natural counter spaces which invite infills, such as the celtic display capital P on the left. Many luxurious manuscripts from the middle ages show enlarged 'historiated' initials containing complete scenes from the text, while others may contain 'inhabited' initials that are filled with figures or animals, again related to the accompanying text.

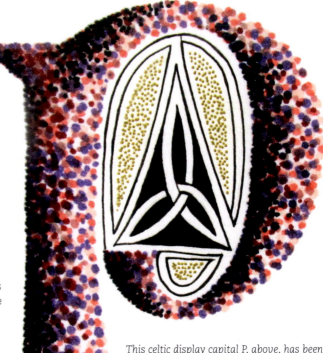

This celtic display capital P, above, has been created using the stippling technique described on page 100, with the subtle colours allowing the closed counter space decoration to 'sing out'.

This results in harmonious contrast, with the eye still easily able to see the lettershape. It is important to balance the decoration so that legibility is not impaired. The versal capital D (see right) has stronger decoration on the body of the letter and a delicate silver pen infill. Again, this creates contrast but not a conflict.

Decoration on letters

There are many varied ways to add decoration on to the letterforms themselves, from very simple in application to much more complex. Whether the lettering is drawn with pens, brushes, paints, ink or coloured pencils, the array of differing results from the same techniques is delightfully overwhelming.

This style of decoration works particularly well for styles that are inherently decorative or complex such as celtic display capitals, as the shape of the letter – perhaps unfamiliar to many modern eyes – remains as clear as possible when the background and internal elements are clear. With that said, decoration on the letterforms also works very well on simpler styles. The strong, familiar shapes of roman capitals can support some elaborate decoration, for example.

The elaborate shape of this gothic capital D benefits from the decoration being kept within its outlines. Simple monochromatic colour banding in gouache reinforces the shape of the letter while giving it a beautifully ornamental quality.

Decoration around letters

Decoration around the lettering will inevitably take many forms and is a vehicle for stretching the imagination. The additional decoration can range from gentle backgrounds, to bands running either through or around the letter or word.

Decoration around letters can, of course, be added to letters that are themselves decorated, as in the example on the lower right. This allows for wonderfully intricate and enjoyable freedom in your artwork. Speaking from experience, this type of work can become highly addictive – I just love it!

Dry coloured pencil using pressure and release (see page 67) was used to add a background behind the letters here.

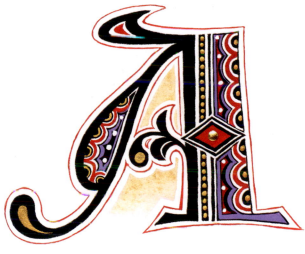

This lombardic A is patterned and decorated using gouache, and the little jewel was gilded as described on page 123. The area within the counter spaces has had a touch of gold watercolour dropped in using the 'wet into wet' technique on page 78.

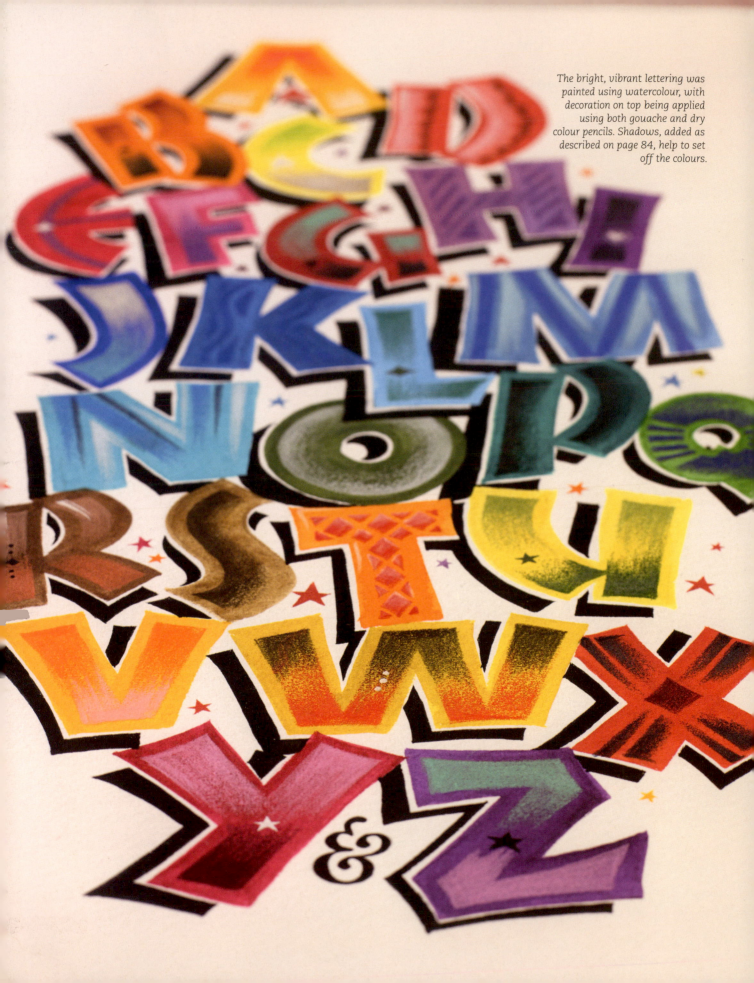

The bright, vibrant lettering was painted using watercolour, with decoration on top being applied using both gouache and dry colour pencils. Shadows, added as described on page 84, help to set off the colours.

Using colour

Welcome to the wonderful world of colour. This part of the book includes a little theory alongside the art of colour, to make its use in your decorated lettering as clear and simple as possible.

The primary colours

Primary colours cannot be created by mixing any other colours together. In pigment, the primary colours are red, blue and yellow. These are called subtractive primaries (see right), as theoretically they combine to create black, or an 'absence of colour' by cancelling each other out.

Secondary colours are the result of combining two primary colours.

Tertiary colours are the hues produced by combining a secondary and a primary colour.

Complementary colours neutralise each other when combined, producing a range of neutral greys. However, when placed next to each other they can create the strongest contrast with very vibrant results – though not necessarily harmonious ones!

Additive and subtractive colour

It is very important to distinguish the difference between the subtractive primaries of pigment – red, blue and yellow – which mix to produce black, and the additive primaries of light, which mix to create white (as on a television screen, for example). These are red, blue and green.

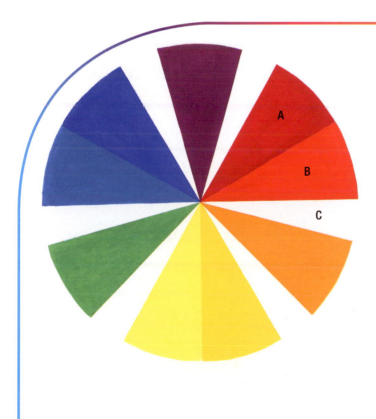

The colour wheel

A colour wheel shows the relationships between the colours it includes. This simple colour wheel includes two versions of each primary colour, each biased or leaning towards its neighbour on the colour wheel. For example, one of the reds (marked A on the wheel) is closer to blue, and the other (marked B) is closer to yellow. This is called 'bias' and becomes important when mixing colours (see page 63).

In addition to the primary colours red, yellow and blue, this colour wheel includes the secondary colours purple, orange and green. These sit between the two primary colours from which they can be mixed. Purple is a combination of red and blue, for example.

Tertiary colours have been left out of this colour wheel for clarity, but they would fit in the spaces between the primaries and secondaries from which they are mixed. The reddish-orange colour mixed from red (primary) and orange (secondary) would sit in area C, for example.

Complementary colours are found directly opposite one another on the colour wheel: red and green, blue and orange, and yellow and violet are each complementary pairs of colours.

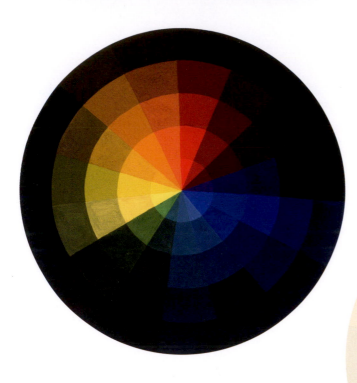

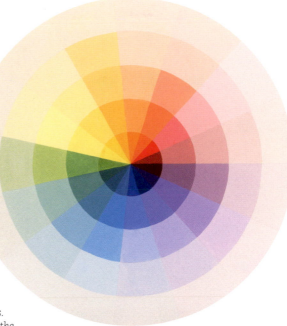

Tints and shades

These more complex colour wheels include tertiary colours and also demonstrate tone. Tone is simply how light or how dark a colour is. Light tones are called tints. Tints are the magical range of colours produced by combining a full strength colour or hue with white. Shades are the opposite: the colour range produced by mixing a colour with black in varying amounts.

Both of these colour wheels were painted with the pure hue in the centres. The surrounding tiers increase in shades (above) and tints (right), to show the great variety of colour and tone available through mixing.

Choosing your paint palette

You do not need to buy lots of different colours. A basic palette of eight paints – two versions of each of the three primary colours, plus black and white – will enable you to mix almost any colour you choose in either gouache or watercolour.

Below I detail two suggested palettes for you to use, but they can be varied as long as the chosen colours are similar in their bias to those in the list. As with much in life, there are many exceptions to the 'rules' and reading up on the background of the colours and brands can help. However, you might prefer simply to see what fun you have experimenting and trying them out!

White for mixing

Zinc white is the most translucent white and best for mixing colours as it produces a clean colour tint. Being translucent, it has the weakest hiding power and as a result does not work well covering darker colours.

Gouache

Blues Ultramarine blue and phthalo blue.

Yellows Lemon yellow and spectrum yellow.

Reds Flame red and alizarin crimson.

Watercolour

Blues Ultramarine blue and cerulean blue.

Yellows Winsor lemon and cadmium yellow.

Reds Cadmium scarlet and alizarin crimson.

Mixing colours

When mixing pigments, it is vital to understand the need for two versions of each primary colour, each biased or leaning towards its neighbour on the colour wheel, (see page 61). It is easier to mix a colour of your choice if you know the required bias of the 'parent' colours. The colour wheels on the previous pages will help to guide you in selecting which particular colours to use.

This principle applies to all media, whether pastels, pencil crayons, gouache, watercolours, acrylics or oil paints, as they are all created by combining particular pigments with a specific binder to enable them to adhere to the surface on which they are applied.

The closest two primary neighbours on the colour wheel will produce the most vibrant secondary colour.

Two purple mixes

The upper example shows a purple mixed from a blue paint that leans towards red, and a blue-biased red paint. The result is a clean, vibrant purple.

The lower example shows a mix of yellow-biased blue and yellow-biased red. The result is a murky brown-purple.

Mixing for effect

Sometimes it is desirable to mix colours that are biased away from one another in order to get a particular effect. The example on the upper left shows a vibrant, spring green mixed from blue-biased yellow and yellow-biased blue. Compare it with the muted, natural olive below it, mixed from red-biased yellow and red-biased blue.

Similarly, an orange made with the red and yellow biased towards each other, as shown in the upper right, will be brighter than one made with the primaries biased away from each other, as in the lower right. Experiment with the intermediate colours as well, using one primary biased towards the intended mix and one away from it.

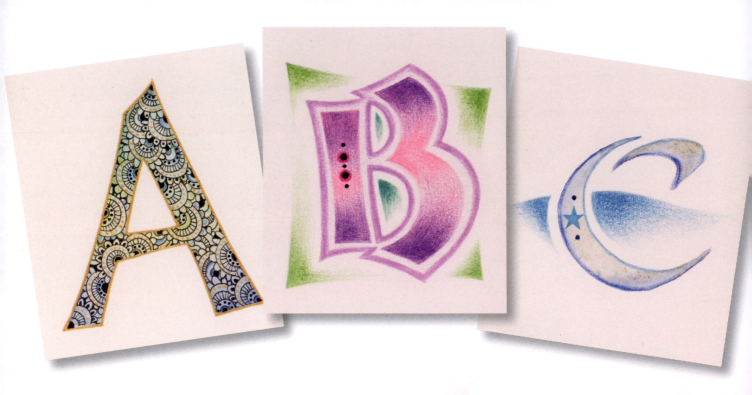

Wet and dry colour blending

Coloured pencils are a really versatile medium which respond rewardingly to sensitive changes in pressure. The techniques in this chapter use watersoluble coloured pencils for both dry colour and also with water added. However, these dry colour pressure and release techniques can be achieved equally well with non-soluble coloured pencils.

Initially, the sensitive variations in pressure need a little practice to achieve the delicate blending and the more gentle the strokes, the more successful you will be. It must be emphasised that using quality is particularly important when using coloured pencils, as cheap imitations really will disappoint. Use artists' quality wherever possible for sumptuous results.

Above, left to right:

The capital A was coloured using the blending technique on pages 68–69. Extra dry colour was added once dry, then gouache gold dots were added along with a gold outline to complete the design.

The B was coloured using the pressure and release technique on page 67. Small additions on the middle of the letter add a focal point to the overall design.

The C was drawn as described on page 95, using two watersoluble pencils taped together. Water was brushed over and between the coloured outline, allowing the colours to become soluble and to blend freely. While still wet, a little powdered gold gouache was sprinkled on. Once dry, additional decoration was applied to the letter and extra colour added with the pressure and release technique.

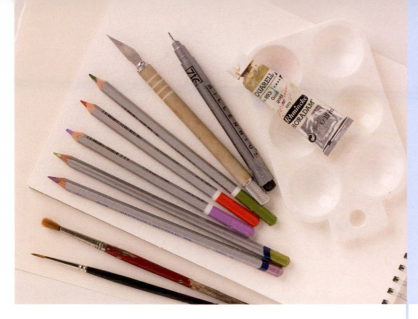

You will need

White hot-pressed watercolour paper, 300gsm (140lb)

Good quality, watersoluble coloured pencils

Craft knife

Waterproof fineliner pen

Gold watercolour paint

Powdered gold gouache

Sable brushes, mixing brushes and mixing palette

Preparing your pencils

Whatever sort of pencils you are using to decorate your lettering, it is important to use pencils with good, sharp ends to give you more control and precision.

I recommend sharpening your pencils with a craft knife, cutting away from you into a small receptacle. This allows you to control the length of the pencil tip, and ensures a fine, sharp end.

Gold

'Tro-col bronze' powders are dry metallic, powdered pigments combined with dextrin, a dry glue binder. The powder can be mixed with water to a working puddle, but when sprinkled onto wet areas of gouache, watercolour, inks or wetted areas of soluble coloured pencils, it produces an exciting glossy, sparkling effect. The binder is activated when wet, ensuring the mixture adheres to the paper on drying. Dip a damp brush into the glass jar to lift the powder to sprinkle.

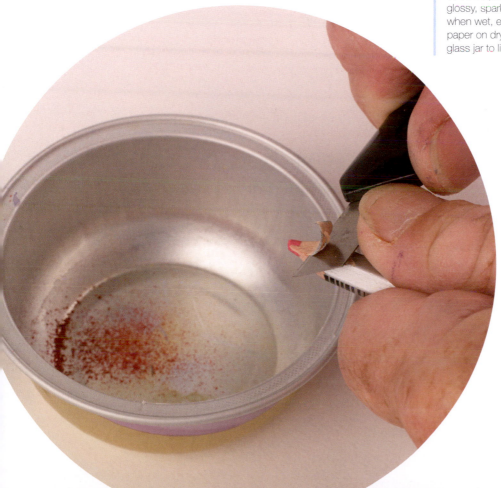

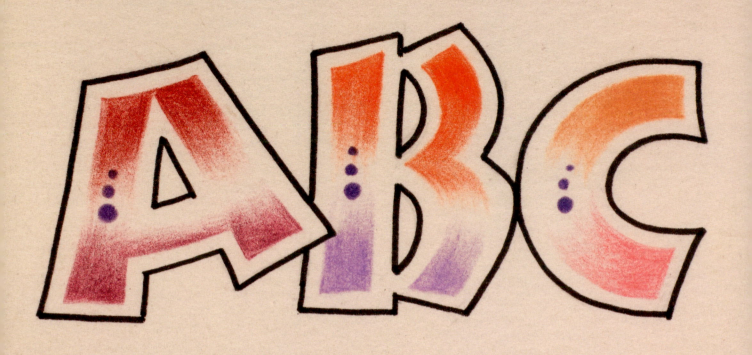

Initially drawn with a fineliner pen, these letters were decorated with coloured pencils using the pressure and release technique described opposite.

Pressure trials

Do not be tempted to rush when using coloured pencils, as you need to work and rework areas to build up a gradual deposit of colour to give an even coverage. It is important not to put too much pressure too soon on the coloured pencil, as this will result in a shiny surface that rejects further colour. To increase the depth of tonal shading and contrast, gradually increase stroke pressure, laying down more and more pigment until full depth is achieved.

As you colour, vary your stroke directions to achieve an even covering. To blend in a second colour, gently 'glaze' it over the top with the same lightweight strokes. Work the colours equally as you gradually build up full colour depth.

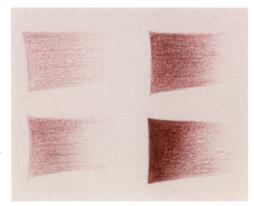

Practise building up pressure slowly on a spare piece of paper to see the depth of tone and richness of colour you can achieve.

Pressure and release

Pressure and release is the technique used to achieve gradations of colour, variations in stroke thickness, and 'hard' or 'soft' edges using your coloured pencils. This is done by sensitively changing the amount of pressure applied during colouring. Try not to change suddenly with a crude 'on or off' approach. Instead, gradually release the pressure to achieve the subtle changes of density and a feathered, soft edge opposite a crisp-edged end, as shown in the examples on these pages. Keep the tip of the pencil sharp to ensure any hard edges are crisp, and aim for a good contrast between the lightest and darkest areas.

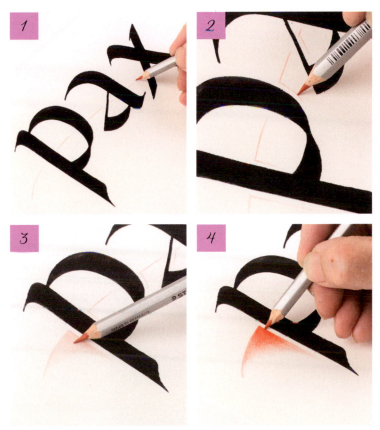

1 With your lettering drawn out, draw a fine undulating line through the letters using a coloured pencil. Use very little pressure – this is intended as a guideline. Leave a small gap between the edges of each letter and the line. This has the effect of increasing both contrast and interest.

2 On each section of the line, add a single stroke that follows the shape of the adjacent letter edge. This forms a corner on each part.

3 Using a very light touch, draw strokes that radiate from the corner and fade out to nothing. Hold the pencil a long way back so that the pressure is very light indeed.

4 Strengthen the colour towards the corner by repeating the technique using slightly more pressure. With each pencil stroke, release the pressure towards the end so that a natural gradation occurs. Build up the tone in repeated layers. Do not be tempted to rush and use a lot of pressure immediately, as this can result in a shiny effect. Work gradually to build up the tone.

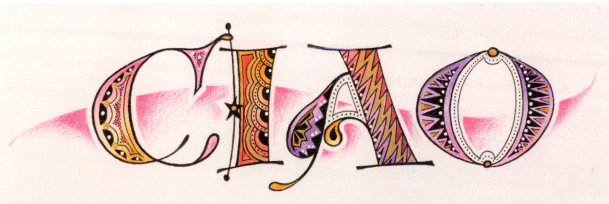

The pressure and release technique was used to add an attractive pink background to this piece. The additional background colour really helps to make the decoration within the letters sing out.

Blending coloured pencils

The blending, or graduating, technique described here will work with any pencils, including soft graphite. However, the colour-mixing possibilities are increased using watersoluble pencils, as you can gently blend the colours by brushing in clean water.

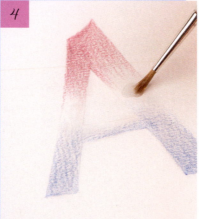

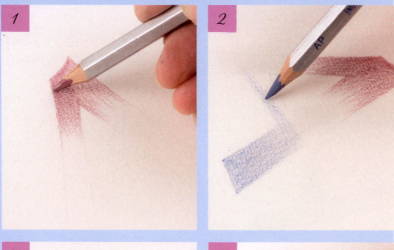

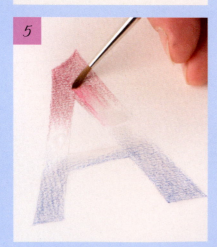

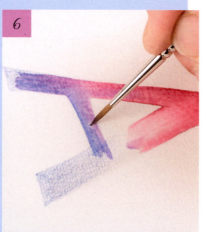

Test your paper

The paper surface you use will subtly alter the effects of this technique, depending on whether the surface is smooth or textured. For this reason, it is important to do trials.

1 Draw out your letter as faintly as possible using a 2H pencil. Using a sharpened pink pencil, colour in the top part of the letter using light strokes. Aim to create an even coverage, feathering the colour out towards the centre.

2 Choosing a colour that will combine to make a good mix (in this case, blue), begin to colour in the lower part of the letter. Again, use light pressure and turn the paper if necessary, rather than trying to colour at awkward angles.

3 Continue to fill the lower part of the letter, feathering out the colour towards the middle, leaving a small amount of space between the areas of colour. You may need more than one drop of water.

4 Using a size 1 round brush, drop a little water into the gap between the areas of colour.

5 Working quickly, draw the water up into the top area of colour, staying within the edges of the original pencil marks.

6 When the colour has become soluble, gently draw the liquid colour down into the lower part. Turn the paper as necessary to reach awkward areas.

Backruns

Try not to have to introduce more water at stage 6, as this can result in unwanted drying stains called 'backruns'. These are caused when the initial wetted area has started to dry and the newly added water moves the pigment around.

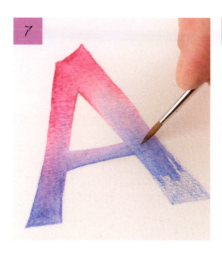

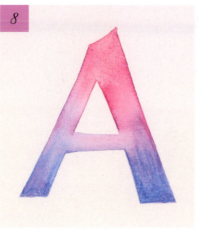

Guidelines

Marking a faint inner line that follows the exact profile of the outer shape can help guide you when filling in with the pencil.

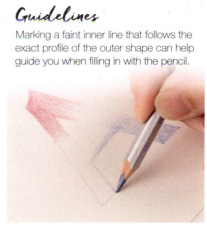

7 Continue working until the whole letter is all wet.

8 Leave the letter undisturbed until it is completely dry. It can then be left as-is, or you can decorate on top using other techniques, such as layering (see pages 70–71).

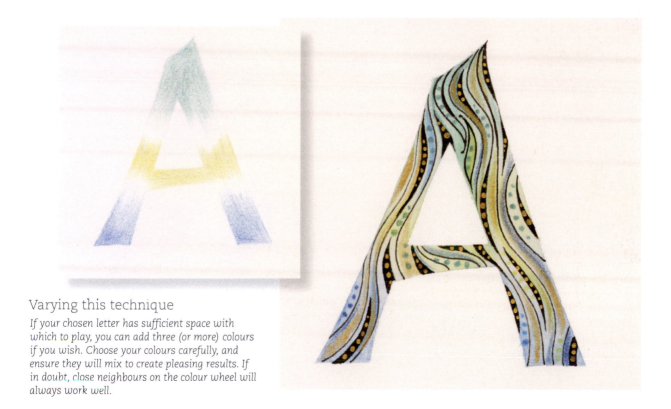

Varying this technique

If your chosen letter has sufficient space with which to play, you can add three (or more) colours if you wish. Choose your colours carefully, and ensure they will mix to create pleasing results. If in doubt, close neighbours on the colour wheel will always work well.

Layered decoration

This technique can be used to add detail and decoration over most watercolour and coloured ink surfaces. It works particularly well with letters decorated using the blending technique detailed on the previous pages.

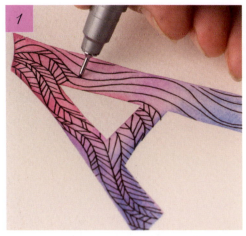

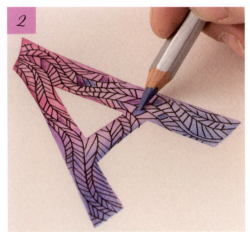

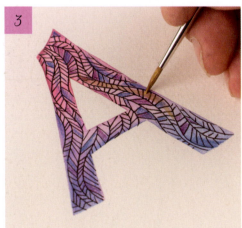

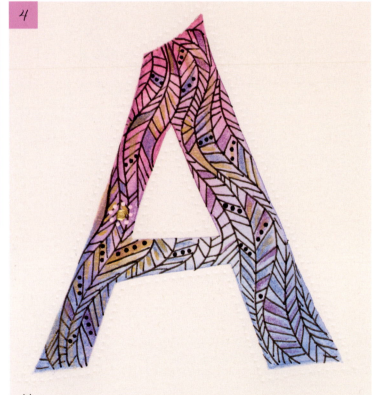

1 Using a waterproof black fineliner, add long, fine wavering lines, then join them with shorter lines.

2 Fill in some of the smaller areas this creates with the same watersoluble pencils you used earlier. Use more pressure to increase the tone.

3 Prepare a working puddle of gold watercolour (see page 18) and use a size 1 round brush to colour in some other areas suggested by the pen lines.

4 Continue decorating to your satisfaction using the coloured pencil, fineliner pen and watercolour.

Using this technique

These examples show variations on the basic technique shown opposite. The left-hand example has a background ribbon produced as described on page 67, and a floral motif with gilded jewel-like dots on the letters themselves. This technique can be found on page 123. The right-hand example has a linear border and a simpler surface pattern.

The strip along the bottom shows numerous examples of different colours and patterns that use the same technique.

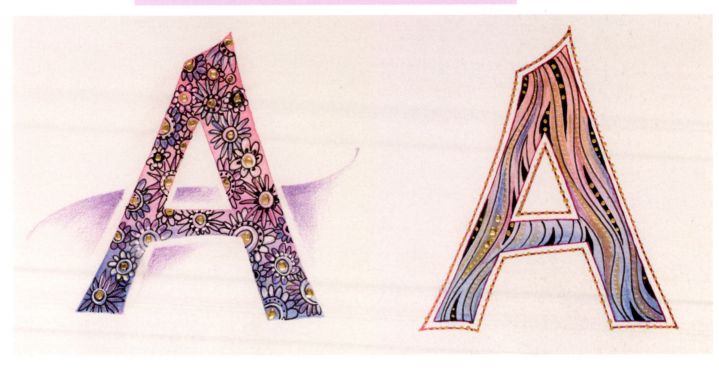

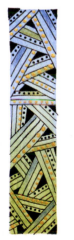
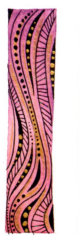
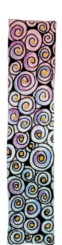
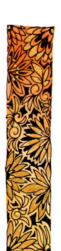

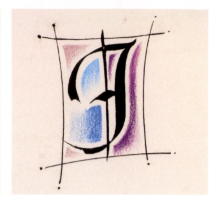

Greetings card background

This birthday greetings card uses the pressure and release techniques on page 67 to give a varied background to the message. Note that a slim border of clean paper is left so that the text stands out.

Pen-drawn letters with pressure and release backgrounds

The V has a background made up of two different greens. The first was applied as an 'underglaze', and the second colour was applied gently on top, allowing some of the original colour to show through. The J was worked in a similar way, but using distinctly different colours for a more striking effect.

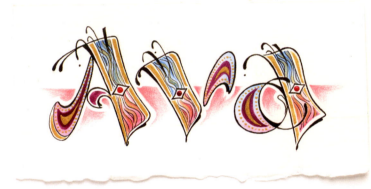

Room nameplate

I enjoyed using freestyle letters (see pages 46–49), choosing colours and patterns that I thought Ava would like. The beauty of these letters is the creative freedom you can use to decorate them to fit the personality of the recipient.

A B C

These letters show the results of further experiments with the techniques in this chapter.

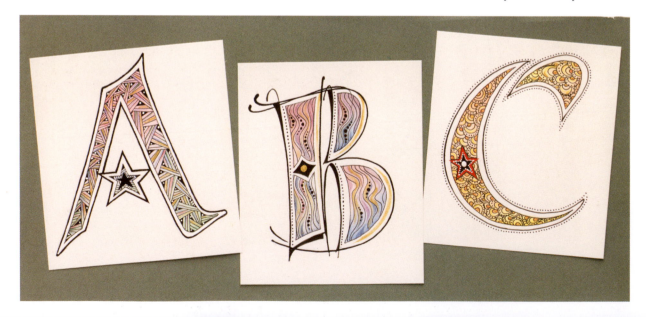

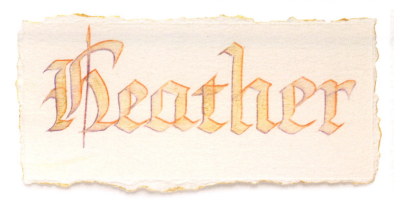

Heather

The outlines of these gothic letters were drawn using two watersoluble pencils taped together, using a method similar to that on page 95. Using a brush, water was run between the two outlines, so the two colours lightly mixed on becoming soluble. While the letters were still wet, I individually touched each with a brush loaded with gold watercolour.

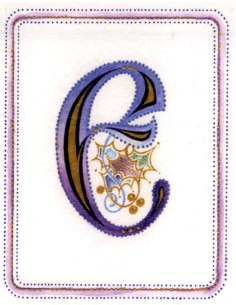

Celtic decorated E

This letter is one of the more rounded versions from page 51. I have changed the traditional 'zoomorphic' decoration (with animals) for an interwoven holly embellishment. As long as your design is in keeping with the theme, don't be afraid to experiment.

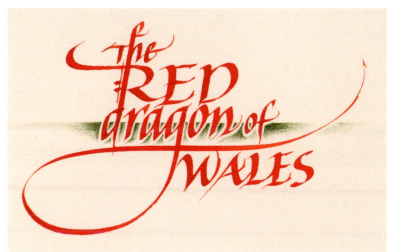

The Red Dragon of Wales

The additional green decoration, produced with the pressure and release technique, uses colours that complement the text and evoke the red, white and green of the Welsh flag. The flourished tail of the italic minuscule 'g' has been extended to suggest the tail of the dragon.

Peace and Laughter

These examples show crisp bands of colour and are an example of free colouring between the letters.

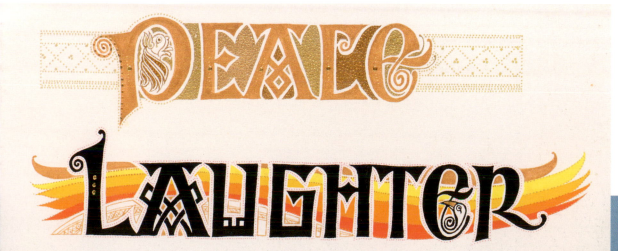

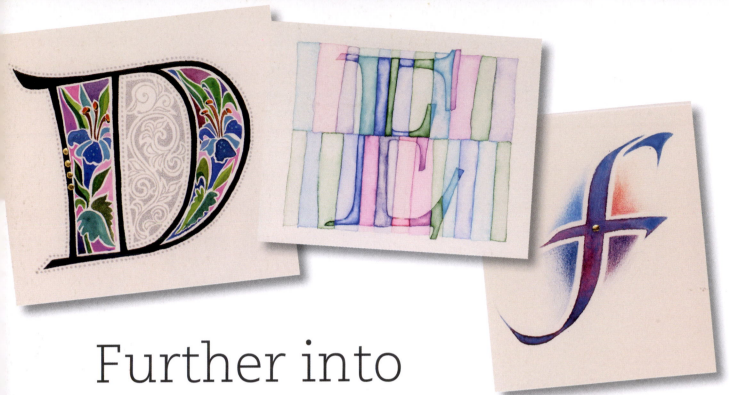

Further into the world of watercolour

The world of watercolour is an absolute delight and can be both rewarding and frustrating in equal measures! Having made a great start using watersoluble pencils, we now move on to conventional watercolours. Watercolour paints are relatively transparent, allowing the white paper to show through and come in four categories: transparent, semi-transparent, semi-opaque and opaque. The opaque colours have almost the same density as gouache.

For larger areas such as backgrounds, tubes might be better, whereas for writing, watercolour pans are ideal, as you only take a small amount of colour on your mixing brush in order to fill your pen. However, as long as you use artists' quality paint, tubes or pans are equally good, whether used for writing or for producing delightful backgrounds.

This chapter will cover various wet into wet techniques, using both brushes and pens. The possibilities and potential are enormous and experimentation will give huge pleasure.

Above, left to right:

A simple floral design has been painted within the outline of this versal D. A white gap was left between colour changes, which breaks the design into parts, resulting in an appearance similar to stained glass. A silver gel pen has been used to add extra decoration and dots within the letter.

This cross-hatched panel with drawn Roman capital E was made using watercolour. The strength of colour was then altered by lifting out pigment as described on pages 76–77.

The italic F was drawn using a pen loaded with watercolour. While still wet, a second colour was applied using the dropping in technique on page 78. Dry colour was added around the letter using the pressure and release technique from page 67.

Preparing watercolour

Watercolour paint in tubes can be simply squeezed into a palette well and prepared as described on page 18.

Pans of watercolour must be mixed into creamy working puddles like any other writing fluid. Wet your brush with clean water and gently agitate the surface of the pan until you achieve the right consistency.

prepared as described on page 18.



You will need

Artists' quality watercolour paints (tubes or pans)

White hot-pressed paper 300gsm (140lb)

Several sizes of sable brushes and mixing brushes

At least two water pots

Edged pens, pointed pens and fineliners

2H pencil



COLOUR LIFT-OUT

Lifting out

Whether used on letters or as a patchwork background, this technique is very effective. It relies on using a clean, damp brush to gently soak up excess fluid, gradually 'lifting out' the liquid which will remove an amount of colour. The degree of colour able to be lifted out will depend on the character of the individual pigments, and what you wish to achieve.

Shapes can be left a short while if you are proceeding to paint other areas, but it is important not to allow the area of colour to dry, as it will make it difficult to lift out, so keep flooding the area with clean water to prevent it from drying.

Depending on the paleness of colour required, keep adding more water and repeating the lifting out process. Carefully prod the drying edges with your brush to achieve the desired 'crustiness'.

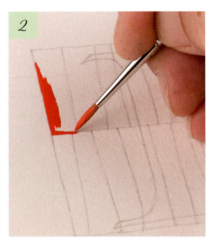

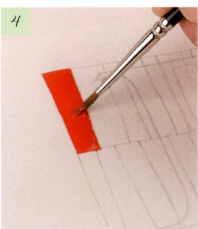

1 Draw your initial shapes using a 2H pencil using the lightest line possible, then add a loose grid over the top. Prepare your watercolour.

2 Use a size 1 sable brush with a good point to paint an outline around the perimeter of your shape to define the limit of the wet area. Once complete, flood the area with full-strength colour, as it will not go beyond the wet edge.

3 Rinse out the brush in one pot of water, then load your brush with clean water.

4 Touch your brush to the wet paint to drop a little clean water into the area.

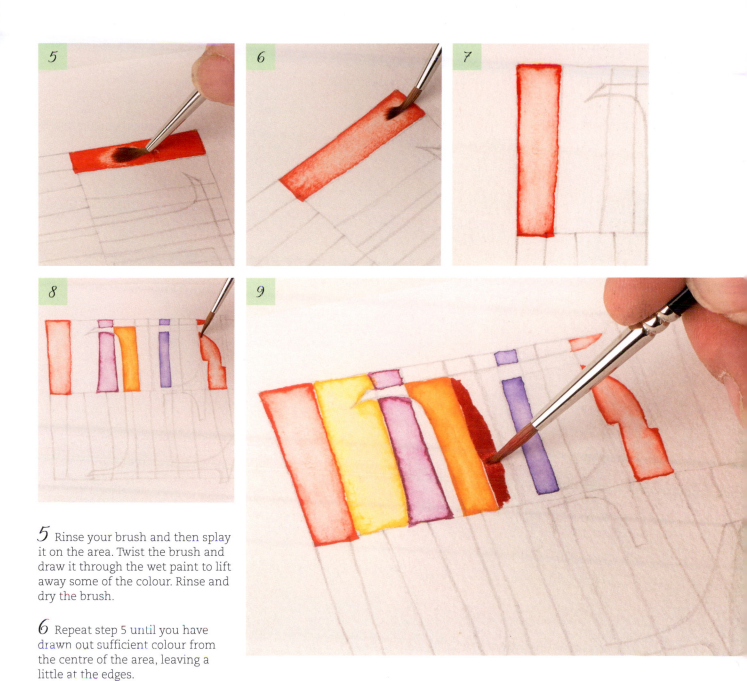

5 Rinse your brush and then splay it on the area. Twist the brush and draw it through the wet paint to lift away some of the colour. Rinse and dry the brush.

6 Repeat step 5 until you have drawn out sufficient colour from the centre of the area, leaving a little at the edges.

7 Allow the area to dry before continuing.

8 This technique can be time-consuming, so you can work on non-adjacent areas while previous areas dry. This reduces the risk of the wet colour touching and bleeding between areas.

9 Once the first areas have dried, you can safely work into the areas between them.

Dropping in

This technique is also called wet-into-wet. The example shown below shows colour being added with a brush to wet calligraphic lettering drawn with a pen, but the technique can be applied across larger background areas or combined with other techniques.

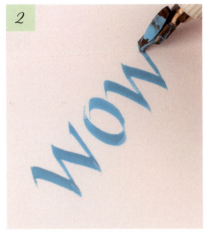

Longer phrases

For longer phrases, write a few letters at a time to avoid the first colour drying before the second colour is dropped in.

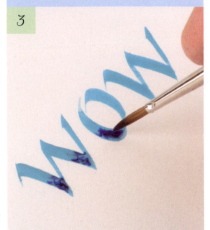

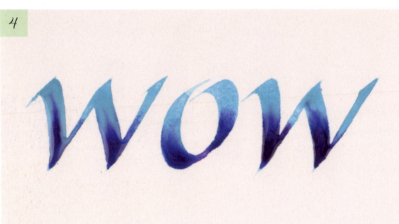

Backruns

When dropping in colour, don't have your brush too wet. This will help reduce the appearance of backruns which occur when extra liquid is added after the initial liquid has started to dry. As watercolour is re-soluble when dry, it is possible to blend these accidental drying marks using a dampened brush.

1 Choose two watercolours and mix working puddles (see page 18) of each. The first will be applied with the pen, while the other is ready to add a second colour into the wet letters using a brush. Dilute the puddles a little more than usual. The mix should be a little watery to allow the delicate transparency to become apparent, but be prepared to experiment, as individual pigment reactions can be quite different.

2 Load your pen with the lighter of the two colours, and write out a few letters – not too many as they must remain wet when adding the second colour.

3 While the liquid remains wet, load a size 1 round sable brush with the second colour and gently touch the tip to a point on the lower half of the letter, allowing a little colour to flood into the still-wet letter surface.

4 Allow the darker colour to bleed into the lighter, then let the fluid dry naturally. Working on a slope will ensure that the new colour stays in the lower part of the letters, but you should feel free to experiment.

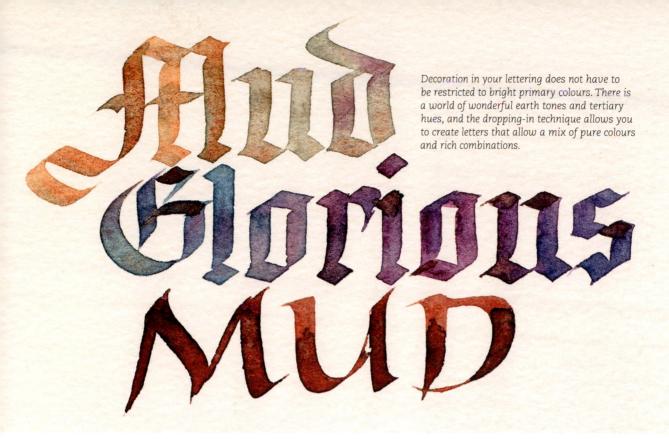

Decoration in your lettering does not have to be restricted to bright primary colours. There is a world of wonderful earth tones and tertiary hues, and the dropping-in technique allows you to create letters that allow a mix of pure colours and rich combinations.

Mixing

Mixed and combined colours

While an area of colour is laid in and the area still damp, you can create interesting effects by touching a brush loaded with a small amount of another colour to the surface.

Adding gold watercolour or sprinkling on imitation gold powders while the letters are still wet can have stunning results and is worth experimenting with. An alternative is to add gold watercolour into the writing fluid already in the nib.

Always use a minimum of two pots of water when using and mixing watercolours – dirty water dulls and muddies the colours.

Colour change – mixing in the pen

Instead of dropping in colour, try changing the colour in your pen as you are writing out your text. It is important that this is done gradually and that you do not have sudden changes.

To do so, start writing your text with your first colour. Before you need to re-charge your pen with more fluid, clean your mixing brush and introduce a small amount of a new colour into the nib without first washing the nib, allowing the original colour to mix with the new one.

As long as you keep the amount of paint you add small, nothing will be immediately obvious. Every few letters, add a little more into the nib, and this second colour will gradually become the dominant one.

You can continue writing with the new colour, or repeat the process by gradually introducing a third and subsequent colours – it is such fun. At first, practise using immediate neighbours on the colour wheel – then experiment and be prepared to be surprised and delighted… just as I was with the artwork at the top of the page.

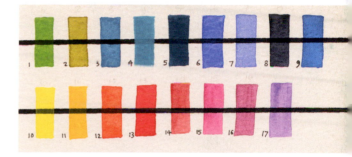

Transparent and opaque paints

Nothing compares with knowledge gained by discovering facts for yourself and making a handy reference chart. Draw a line with a permanent black marker pen on a sheet of watercolour paper. Paint a small block of full-strength watercolour across the line to test the opacity of each of your paints.

This can be especially useful when deciding on which colours could work well together when working wet into wet. For example, cobalt turquoise light (top row, fourth from left) is very dense and almost obscures the black line when worked neat. However, when slightly diluted, it can work well, as shown in the word 'wow' opposite.

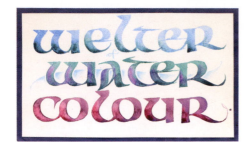

Welter of water colour

Colour was dropped into the wet letters using a brush, using the technique on page 78.

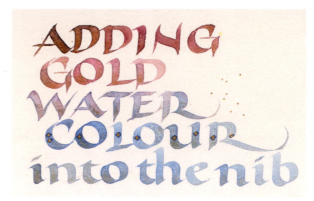

Adding metallic paint

Gold watercolour (or watered down gold gouache) can be added for exciting effects. Here, gold watercolour was introduced into the nib to mix with the other colours, as described on page 79, under mixing in the pen.

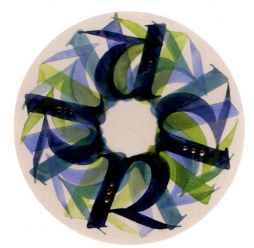

Multiple overlaid layers

Take full advantage of the transparency of watercolours by overwriting several times, and allowing each layer to dry before applying the next – as in this example

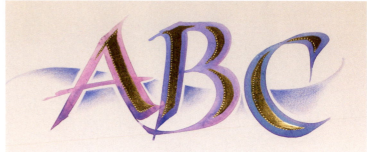

Adding gold

The letters were completed in watercolour with extra colour dropped in wet into wet. Once dry, small areas were gilded as described on page 122, giving an attractive rich result. Finally, dried colour was added through the letters to complete.

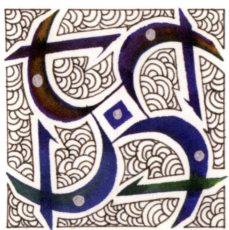

Colour paints the mood

By turning the paper through ninety degrees each time the letter t was repeated, a strong pattern emerges, which is further strengthened by adding decoration in the intervening spaces.

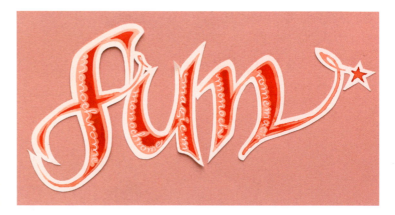

Fun

Once the freely flourished letters of 'fun', written in dilute watercolour, had dried, I used a pointed nib loaded with permanent white gouache to write along the edge of the letterforms. A striking banding effect was added by accurately following the shape of the white lettering using a full-strength red.

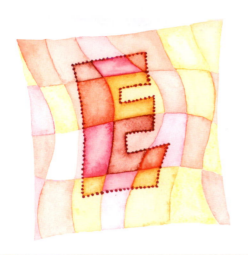

More examples of watercolour techniques

The examples to the left and below show how lifting out colour selectively can complement the meaning of the word. On the left, the word 'waves' is surrounded by a loose grid and made up of wavy lines. Blue and lilac colours further complement the idea. Similarly, the example below uses invisible letters (see page 85) and soft loose application of watercolour to suggest curling smoke, complementing the written word.

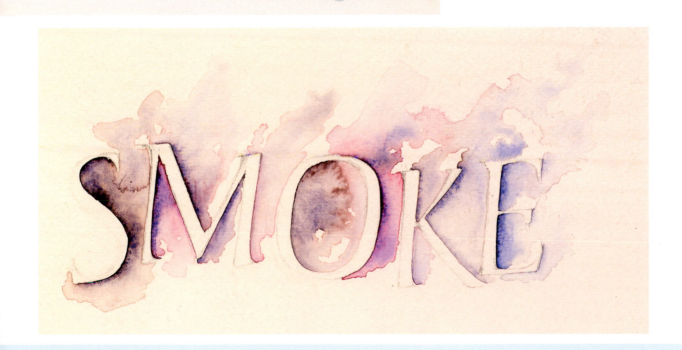

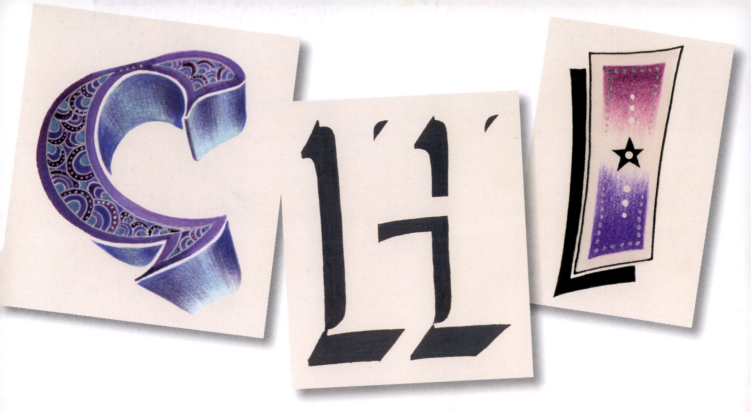

Shadows and the third dimension

When your lettering is given an extra dimension, it will take on a whole new personality. By imagining a light source, you can add 'shadows' and shaded areas, which should fall in the opposite direction to where the light is coming from.

Shadows are literally an absence of light and the minute they are visible, letters and shapes take on a third dimension – depth. Alongside height and width, depth creates form, both in reality and on the page. When a shadow is added, interest is increased and a letter can appear almost to jump off the page. To create this illusion of depth, several types of 'design' shadow can be applied which really make the letter stand out. This exciting, versatile form of decoration creates immediate impact and is perfect for attracting attention on posters, greetings cards and so forth.

Above, left to right:

The uncial G was drawn using the linear perspective technique on pages 86–89. It was coloured using watercolour and additional lines of dry colour added once it had dried. For contrast and interest, decorative markings were drawn on with a silver gel pen and further colour applied.

The H is a good example of an invisible letter. It was produced using the technique on page 85.

The tiny gap between the letter and shadow adds an extra sparkle of interest to this Neuland I. The inside of the letter was decorated with two separate areas of colour that fade towards the mid point using the pressure and release technique on page 67. Silver dots were added to surround the coloured area. The contrasting black star with a white circular centre bring the focal point to the centre of this letterform.

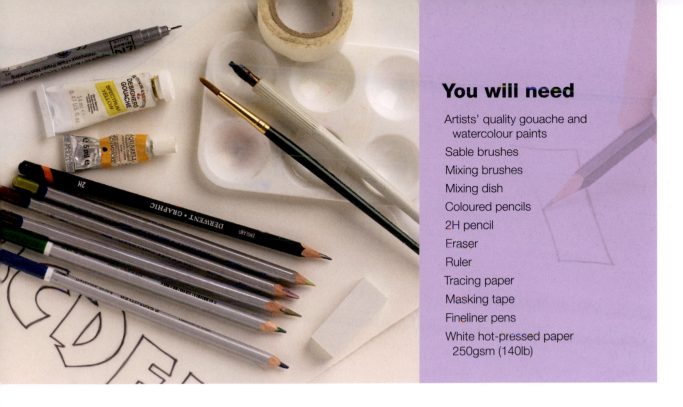

You will need

Artists' quality gouache and
 watercolour paints

Sable brushes

Mixing brushes

Mixing dish

Coloured pencils

2H pencil

Eraser

Ruler

Tracing paper

Masking tape

Fineliner pens

White hot-pressed paper
 250gsm (140lb)

The light source

Shadows rely on light, so to work out where the shadows will be formed, you need to work out a light source. This is an imaginary point which can come from any direction you choose. Shadows are always placed opposite the light source, as they are cast by the intervening object – generally the letterforms themselves.

Once you have decided upon a light source, it is easy to work out where the shadows should be placed. The illustration here shows the effect of different light source placement on a few letters.

 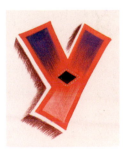

If the light source remains consistent, the shadows will always fall in the same direction, whatever the style of shadow you choose to use.

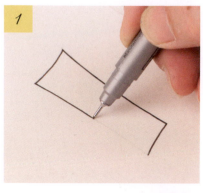
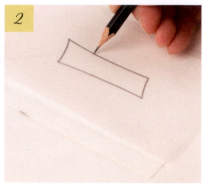

Simple shadows

This technique will show you how to create a shadow of the same shape as the chosen letterform, offset and obscured, 'behind' the letter.

1 Draw out your letter on to watercolour paper using a 2H pencil, then use a permanent black fineliner to reinforce the line.

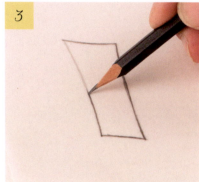
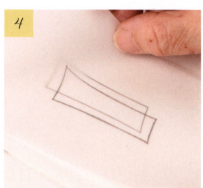

2 Lay a piece of tracing paper over your watercolour paper and trace the letter using a 2H pencil.

3 Turn the tracing paper over and, resting on some scrap paper, trace over the line on the back with the 2H pencil, so that the image will later transfer easily.

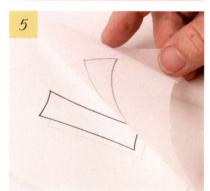
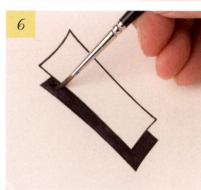

4 Turn the tracing back over and replace it over the letter, setting it a little off the original position. This will form the shadow, so the placement will depend on your light source.

5 Draw over the tracing to transfer the pencil, but work only over the area outside of the confines of the underlying letter. This will leave the faint appearance of a shadow behind the letter.

6 Fill in the shadow area however you like. Here I have used black gouache and a size 1 round brush.

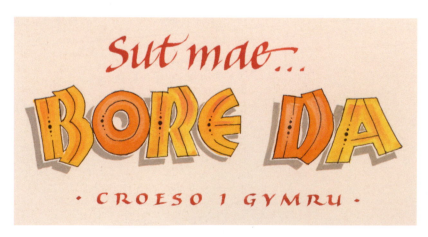

Bore da
Using a grey tone instead of black for the simple shadow gives less contrast for a more subtle result.

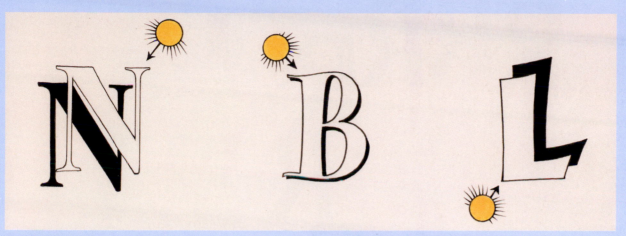

Shadows, light and distance

The placement of the light source can be used to create different effects with simple shadows. If the shadow is physically touching the letter, as in the B above, the result is the illusion that the letter is resting on the surface. A shadow further away suggests the letter is lifted completely away from the surface, as in the N above.

Three-dimensional shapes

A quick way of converting a shadowed letter to a solid three-dimensional version is by filling in the triangular spaces left between the edge of the 'shadow' and the letter, transforming the illusion into a solid, chunky letter that appears to have sides.

Build up the letter as for shadowing, then simply join the corners. The letter outline can either be left in place, as in the example on the far right shown here, or (if you work the first shape in pencil) be erased to leave just the dark areas of the three-dimensional shape, as shown below.

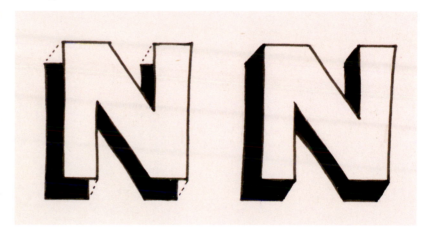

Invisible letters

Bold three-dimensional letters and words are often visually strong enough to allow you to read the wording from the shadow alone. This can gives the illusion of invisible lettering.

Work the shape in pencil. Once you have completed your three-dimensional letter, as above, try erasing the letterform itself, leaving only the shadow.

As if by magic

When preparing letters to create the invisible effect, draw them within a carefully spaced word before applying the three-dimensional block effect. This makes it easier to erase the letters to complete the illusion once complete.

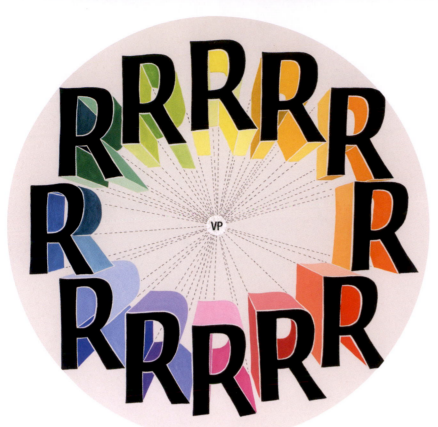

Linear perspective

Linear perspective explains how objects appear to shrink in size according to their position and distance from the viewer. The idea is attributed to the fifteenth-century architect Filippo Brunelleschi.

The technique relies on vanishing points, which are imaginary points on the horizon line of the viewer. It can be used to give letters and words a similar three-dimensional effect to the simple shadows technique, and this is the technically correct way to achieve true perspective. Depending on where objects are in relation to each other, there can be one, two or more vanishing points, but each vanishing point will be on the same horizon line of the viewer, at their eye level.

Single-point perspective

In both of the examples on this page, converging lines meet at a single vanishing point (marked 'VP', in the centre). All the shapes appear to get smaller in all directions as they increase in distance from the viewer.

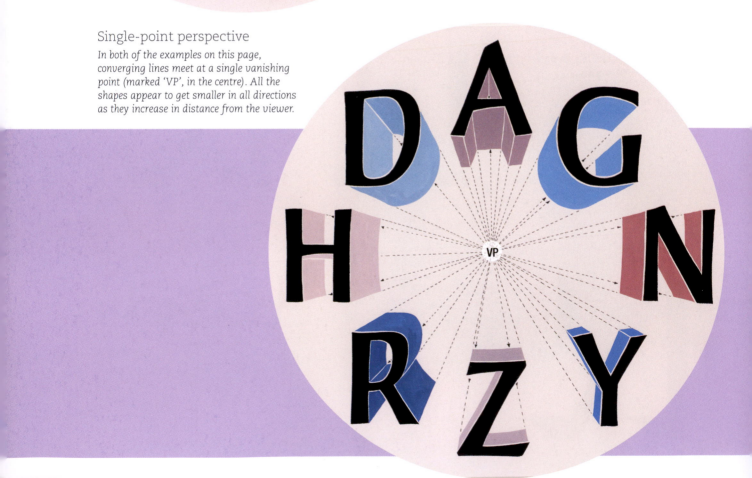

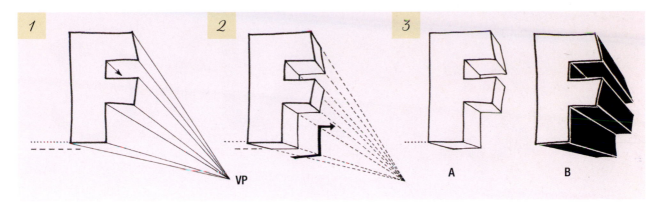

1 Mark a vanishing point (VP) some distance from the letter. Draw your letterform using a 2H pencil. Connect the corners or edges of the letterform to the vanishing point using guidelines made with faint pencil. Some (marked with an arrowhead here) may be hidden behind part of the letter, or other lines.

2 Decide on the depth of your letter (this is marked with a dashed line below the dotted base line in the example above). Use a pencil to follow the exact shape of the letter, changing the direction of the tip at each 'intersection' of the guidelines to create the three-dimensional effect. You can increase the apparent depth of the effect by working closer to the vanishing point (shown by the bold black line).

3 Go over the pencil lines with a fineliner pen, then erase the remaining pencil marks.

Letter in perspective

The technique can create a final effect similar to the simple shadow technique (A) as shown on page 84. If you want a longer shadow for a particular effect, the linear perspective technique described here is more useful (B) to ensure accuracy.

Words in linear perspective

The extended three-dimensional lines used in the linear perspective technique can be shown in a variety of ways and can be applied to any sort of lettering, both graphic and calligraphic. The example to the right shows the effect of linear perspective on a group of italic capitals drawn using an edged pen.

If this technique is to be applied to a complete word, then it is important to completely draw the whole word before applying any perspective techniques, in order to allow words to be drawn and spaced evenly. Occasionally parts of a letter will be hidden by another and you may need to make judgements about where the depth line should go, using clues from other visible parts of the letter.

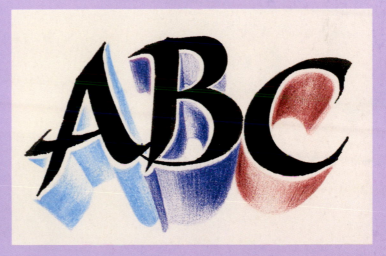

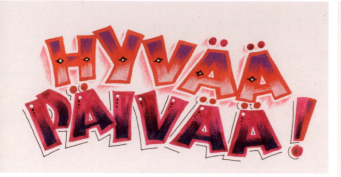

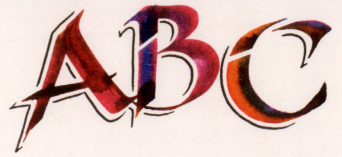

Spacing

A minute space can be left between the letter and shadow, as in the examples above and to the right. This increases the visual impact of your writing.

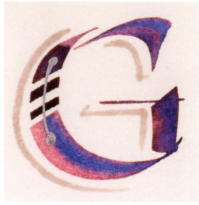

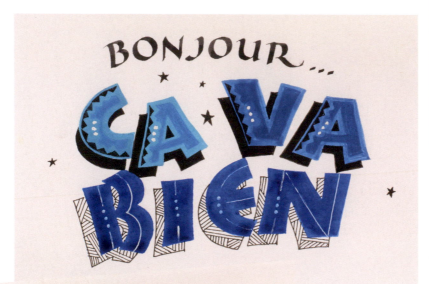

Decorated shadows

Shadows do not need to be flat or dull – strong letterforms like these neuland examples can support surface decoration and elaborately-patterned shadows while remaining clearly legible.

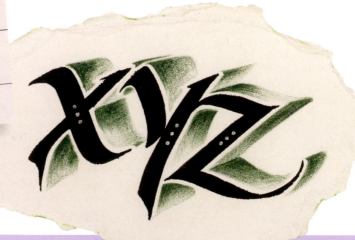

Shadows in combination

Shadows can be confusing with some scripts, so vary the styles you include – using some with and some without shadows.

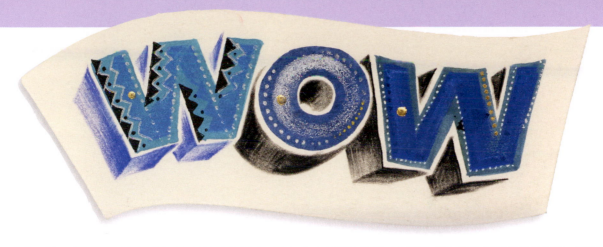

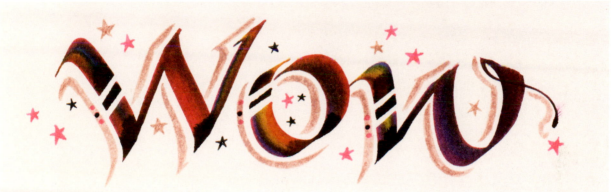

Wow and wow

The 'wow' at the top of the page is made up of painted watercolour letters decorated with dry coloured pencil and gouache decoration. Depth was suggested with the addition of a shadow made with dry coloured pencils.

The example immediately above was written with a pen which was lifted twice on each letter to leave the added sparkle of small white gaps. A linear shadow was applied with a brush-ended marker pen. Small decorative stars also add to the effect.

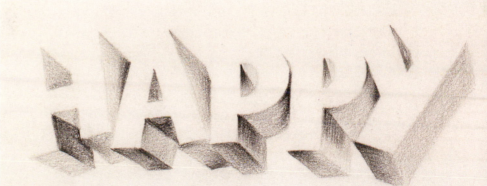

Invisible letters

Depending on the direction in which the third dimension is drawn, single letters can be weakened by this effect as the shape becomes partially lost (see above left). However, they gain strength when in the context of a word, as shown above right. This is because the close proximity of the following letter provides an additional border, increasing the visual information about its profile.

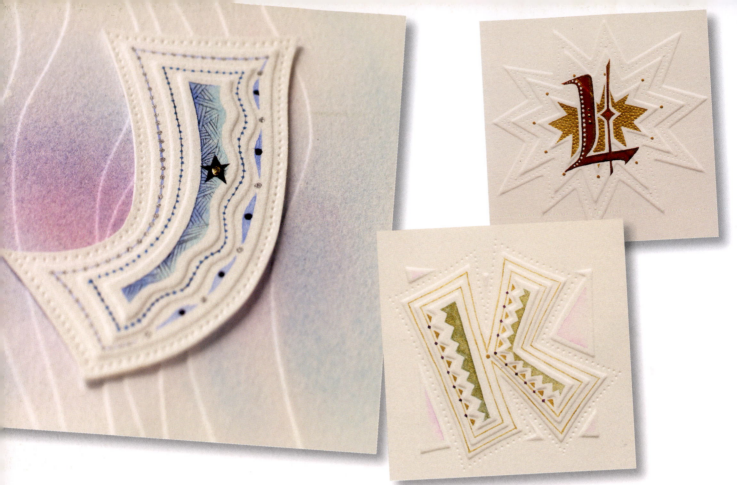

Embossing extravaganza

Embossing is the art of shaping letters and patterns so they are raised above the surface of the surrounding paper, casting gentle shadows to portray their design.

The technique involves carefully and accurately cutting templates from thin card, then gently pushing the paper into the cut shape using a round-headed embossing tool. The actual embossing process is quick and easy to do and once you have cut your template, it can be re-used again and again.

Embossing designs work really well when with calligraphic pieces, particularly for borders and subtle supporting decorations. The technique works equally well as 'stand alone' designs for stunning individual letters.

Above, left to right:

This neuland J was embossed using the technique on pages 92–93. Indented dots were then applied to the front surface and coloured decoration was added. The letter was then cut out, leaving a 3mm (⅛in) border that included the surrounding indentations. The letter was then secured to a background that had previously been rubbed with pastel to give it a blush of colour and embossed several times using a simple wavy-edged template similar to that demonstrated on page 108. A gilded dot was added using the technique on page 123.

The neuland K was embossed exactly as described above, but left in place on the original paper rather than being cut out. The letter itself has been decorated with watercolour, while the background shapes have been left pale, by using watery colour applied with the wet into wet method.

The pen-drawn capital L was prepared on a blank piece of printmaking paper, then embossed repeatedly using a compound circular 'zig-zag' template. The letter was then decorated with a surround of gold watercolour along with indented dots, which were applied directly to the front surface of the work.

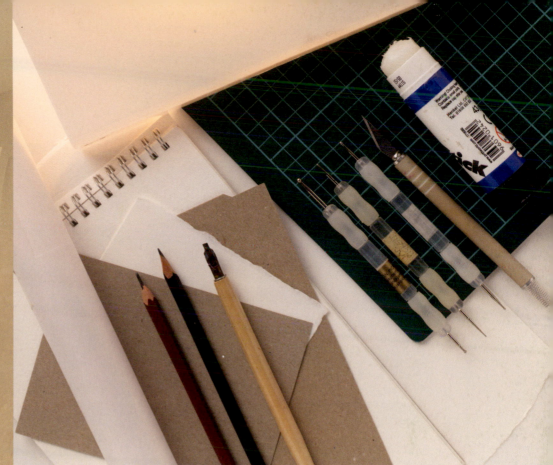

You will need

Embossing tools with large and small heads

Thin plain card – preferably cereal packet thickness

Craft knife, spare blades and cutting mat

Printmaking paper

Hot-pressed watercolour paper, at least 200gsm (140lb) in weight

Edged pens

2H pencils

Eraser

Masking tape

Light box or a window

Gluestick

Artists' quality watercolour paints

Chalk, hard pastels and cotton wool

The charm of subtlety

An embossed design can only 'whisper' its message because the design is created by a shadow alone and therefore has minimal contrast. Care must be taken that the embossing is not overshadowed by stronger elements of any text with which it may be used in conjunction.

The example shown draws the eye to the word 'day' instead of being read as 'G'day', as the contrast of the written letters is so much greater and dominates. Adding colour would help even the balance, but it would be best to leave a gap between the embossed edge and start of any colouring to enable the embossed image to be seen and heard – to colour too closely will effectively 'gag' its voice altogether.

When working on any layout and lettering design, always consider the question 'where is my eye drawn towards?' If the answer is not where you intended, you should redress the balance.

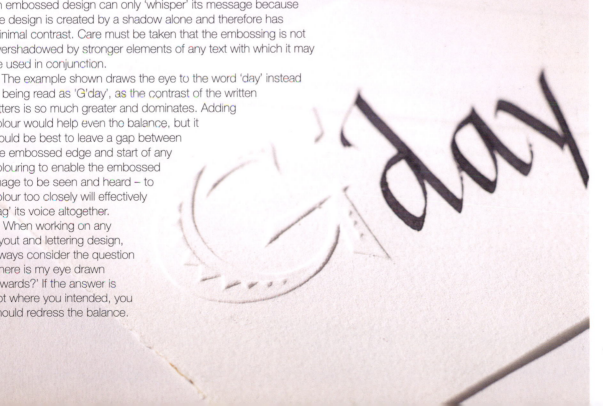

Templates and embossing

Creating a template for embossing can be done with almost any letterform, but fairly bold alphabets, such as neuland, work particularly well as they provide plenty of space for the multiple embossing technique.

The paper you use is particularly important. Printmaking paper yields to the pressure of the embossing tool and bends into shape, whereas papers with a harder surface can crack. For the best results, make your templates from thin card (cereal box card is ideal) and keep the design relatively small.

'No tuft' zone

Imprecise cutting or using a blunt blade will leave tufts in the template that will show up on the embossed image. Overcut corners to ensure clean, crisp cuts and ensure your blade is always a fresh, sharp one.

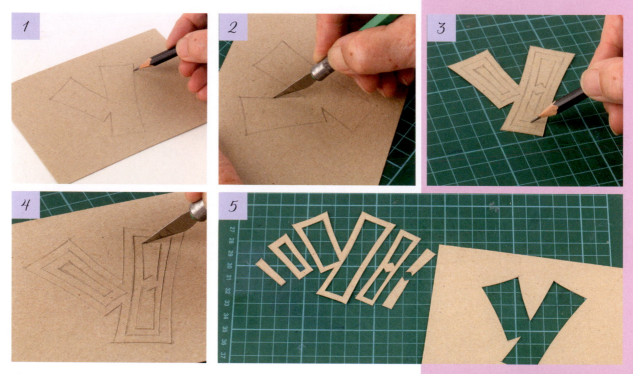

1 Use a 2H pencil to draw out your letter on thin card.

2 Place the card on the cutting mat and cut out the letter shape using a sharp craft knife. Hold the knife comfortably as if it were a pencil.

3 Use a 2H pencil to add additional details on the cut-out letter shape.

4 Place the letter shape back within the template, and use a craft knife to cut out the details. Having the shape supported by the larger template makes it more stable, and thus neater and safer.

5 Put all of the pieces safely to one side. Keep them arranged so that you can easily identify which parts fit together.

6 Turn the main template over and mark it on the reverse side. It is vital that you emboss from this side or your design will be in reverse. I use a cheerful face – that way, when I see a smile, I know I'm doing things right!

Simple embossing

If you do not need multiple layers of embossing, you can skip straight from step 2 to step 7 for a simpler technique.

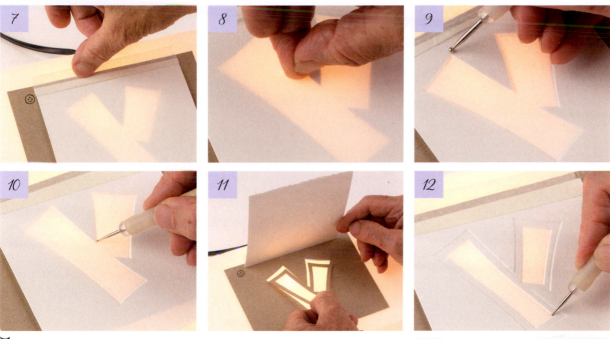

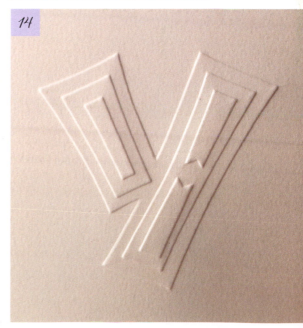

7 Place the reversed template on top of a lightbox, then place your paper on top, slightly offset from the top of the template as shown. Secure both in place using a strip of masking tape across the tops and turn the lightbox on. You should be able to see the reversed letter shape. Run your thumbnail across the edge to ensure the tape is firmly in place.

8 You will now be able to see the reversed letter shape. Run a fingernail firmly around the edges of the shape to make the initial indentation.

9 Run the large end of an embossing tool around the perimeter edge of the letter shape, working firmly against the cut edges of the template. Work the embossing tool over the corners of the template to make sure each one is embossed to a crisp point.

10 Run the smaller end of the embossing tool around the edges to strengthen and sharpen the effect. There is no need to work over the open areas, only the perimeters.

11 Using the masking tape as a hinge, lift the paper up to check the embossing has been worked crisply all round the shape. Keeping the paper out of the way, slip the next largest part of the template back into place within the main template.

12 Lower the paper back into place and repeat steps 8–10 to emboss the inner shape.

13 Once complete, add the final inner section and repeat once more to finish the embossing.

14 Carefully remove the work, then detach the template and store for another time. The image can now be enhanced with additional decoration, if you wish.

Templates for letterforms with closed counter spaces

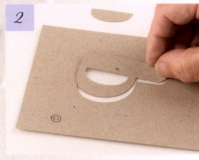

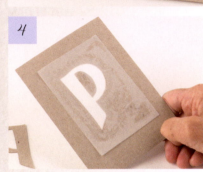

1 Create the template as described on page 92. Cut out a small piece of tracing paper and use a glue stick to affix it to the front of the main template. Be careful to avoid getting glue in the hole.

2 Turn the main template over, draw a smiley face upon it, and put the cut-out letter temporarily back in place within the template.

3 Add glue to the final small piece (or pieces, if the letterform has more than one closed counter space).

4 Remove the letter and turn the template over to finish. The template is now ready to use. Remember that you should be able to see the smiley face until you cover it with your paper ready to emboss – this ensures the result will be the right way round.

Indenting dots

1 Prepare an embossed letter following the instructions on pages 92–93 or above. Place the letter on top of a firm but not rigid surface, such as a cutting mat. Make sure the piece is face-up, or the result will not show. Use the end of an embossing tool to make a small dot, just away from the edge of the letter shape itself, by pressing down firmly on the surface.

2 Using the same firm pressure for each one, add evenly-spaced dots along the edge.

3 Work all the way round the edge.

4 You can also add indented dots within the embossed shape. Take care not to flatten or damage the embossed edge.

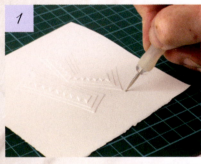

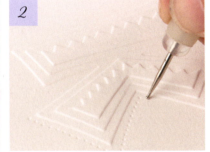

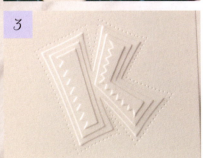

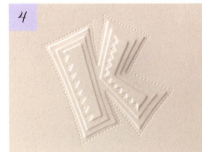

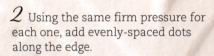

Calligraphic shapes with pencils

This technique allows you to produce calligraphic shapes using pointed pencils or fine-tipped pens. It is useful if you need letterforms larger than your broadest edged nib. Using this method of 'double pencils', great effects can be had using various combinations of watersoluble coloured pencils. Once the letter is drawn, brush water within the boundaries of the letter so the colours mix together. *Heather*, on page 73, is a good example.

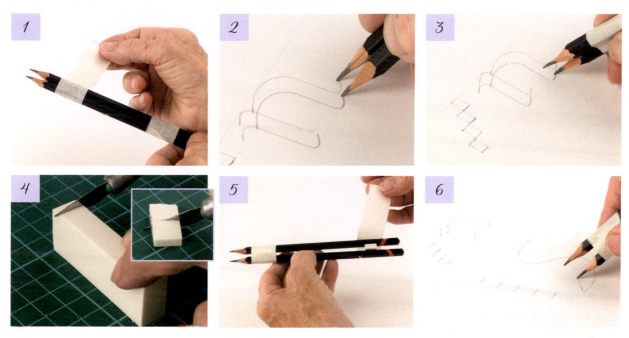

1 Tape two pencils together using masking tape.

2 Keeping your pressure evenly balanced, you can now use them as a single pencil. Imagine that a broad-edged nib spans the space between the tips and use it exactly like a normal calligraphic pen. Build up the correct x-height for your chosen style, rule your lines as normal and take care to use and maintain the appropriate 'pen angle'. The letter shown is a foundational hand minuscule n (see pages 26–27).

3 With your letter shape drawn, you may need to fill the gaps of the missing edges of the serifs using just one of the pencil tips.

4 This approach restricts you to the width of the pencils themselves. If you want to make larger letters, you can add spacers. Use a craft knife to cut off the end of a plastic eraser at the width you require. Cut the piece into two even pieces (see inset).

5 Sandwich the pieces between the pencils: one at the top, one at the bottom. Wrap masking tape round both pencils, to secure the spacers.

6 The size of the spacers will dictate the x-height of the lettering, and thus the size of the letters you can create.

Left or right?

If you are right-handed, tape them so the points are square (below left). If you are left-handed, you can simulate a left oblique nib by dropping the left-hand pencil a little as shown below right.

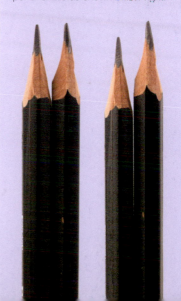

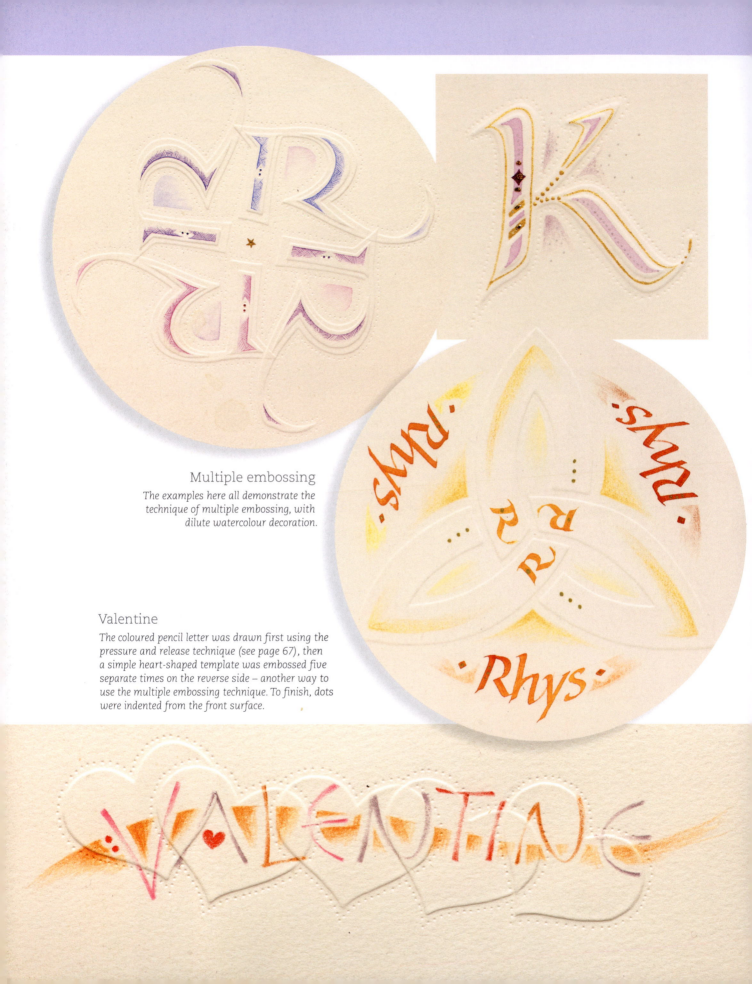

Multiple embossing

The examples here all demonstrate the technique of multiple embossing, with dilute watercolour decoration.

Valentine

The coloured pencil letter was drawn first using the pressure and release technique (see page 67), then a simple heart-shaped template was embossed five separate times on the reverse side – another way to use the multiple embossing technique. To finish, dots were indented from the front surface.

Cats Just Are

The text was written out, before whisker shapes were added using fine strokes. Once dry, the piece was embossed from the reverse side using an paw-shaped template. The piece was then mounted on a sympathetically-coloured piece of handmade paper.

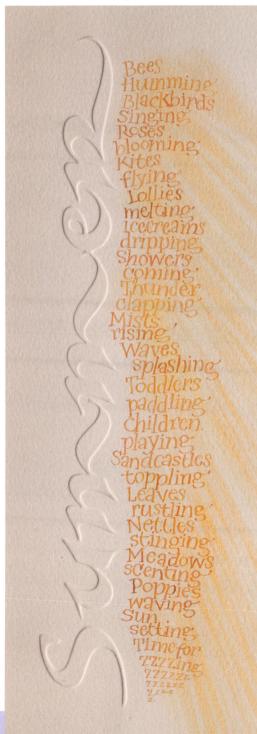

Snail

This illustration has embossed roses on a gentle coloured frame. The 'windows' in the embossed frame and the underlying frame with the text upon it were torn evenly to give a softened wavy edge. The central illustration itself was made with watercolours along with raised and burnished gold leaf.

Summer

This artwork was made with simple open embossing (see page 92), without any further cutting.

Going dotty

The humble dot becomes powerful when packed closely together in areas, especially in forming letter shapes. The technique of using coloured dots creates an optical illusion and relies on the ability of the eye and mind of the viewer to blend the colour spots into a fuller range of tones and also to perceive the illusion of depth.

Colour of light and colour of paint behave in quite different ways and it was artists of the nineteenth century Impressionist movement, like Claude Monet and Georges Seurat, that taught us to make paint behave in the same way as light by dividing up the paint on the canvas, so that it works optically, only mixing during the process of seeing it.

Above, left to right:

An italic m was drawn with taped-together double pencils (see page 95) to ensure calligraphic accuracy, then dots were applied with a brush as described on page 101.

Dots were applied on a bold neuland N which was then embellished with three-dimensional effects as described on pages 86–87. Finally three little 'gold gems', detailed on page 123, were added.

The stippling technique (see page 100) also works well as a technique to fill in areas, as with this freestyle capital O. The dots add depth when added in the spaces of this letter worked in outline. If in doubt, just be prepared to play and experiment!

Pointillism

Pointillism was pioneered by the artists Georges Seurat (1859–1891) and Paul Signac (1863–1935). It uses the stippling technique to apply tiny dots of different colours on the painting surface. Seen from a distance, the distinct colours appear to mix together in a process called optical blending, resulting in vibrant images.

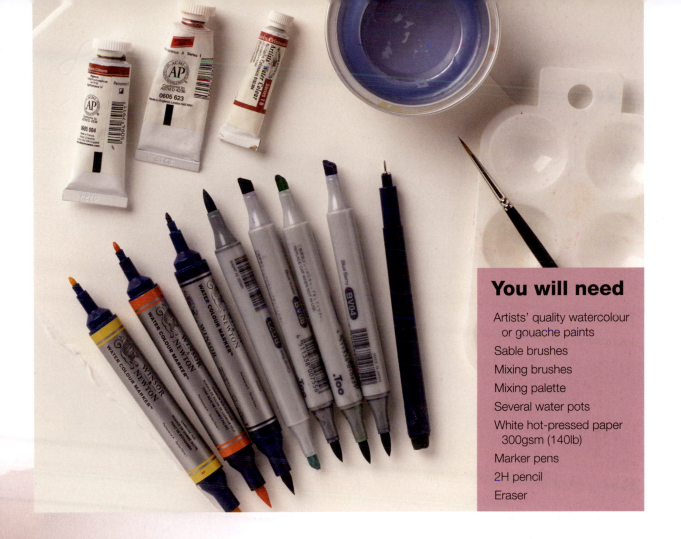

Dots and the light source

This sequence above shows how densely-packed dots of different colours build up to create the letterform. It also demonstrates how effectively shading and form can be suggested through the careful placement of different tones. As described on page 83, the shadow is always opposite the light source, so you will need to decide upon that before you begin the stippling technique (see overleaf).

The finished example on the right shows just one approach for creating form through the use of closely-packed dots and careful thought about the lighting.

Stippling

Stippling is the name given to the technique of painting in which small, distinct dots of pure colour are applied in patterns to form a shape or image. This stippling effect simulates varying degrees of solidity or shading by building the depth of colour. You can build up complete layers of evenly spaced dots for a flat effect, or build up form and depth through careful placement of the dots.

To achieve an illusion of depth, the technique relies on light and shade, so before starting to apply colour it is important to have decided the direction of applied light to know where to build the darkest areas of the letter. It can be your own choice, but the example shown here has the light source at the top right, so the darkest parts fall on the lower left parts.

It is also fun to try this effect with unusual colour combinations or simply black and white alone. Whatever you choose to do, you will be delighted with the results.

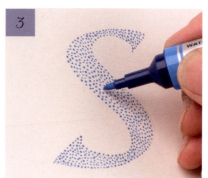

Stippling tip
Try not to allow a regular pattern or lines of dots to become visible; the dots should be closely packed but randomly placed, achieving an overall and even coverage.

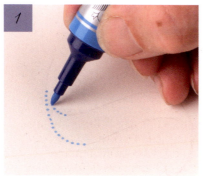

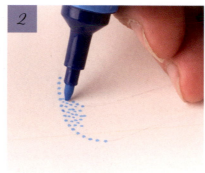

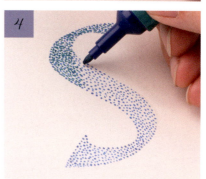

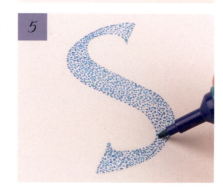

1 Draw out your letter faintly, using a 2H pencil. Starting from the top, use the tip of the of the marker pen to add small dots round the outline of the letter shape.

2 Begin to fill in the space in the middle with dots. Hold the pen more upright than usual, to ensure you are using just the tip. If you are using a brush and paint, then the brush must be as vertical as possible. Pens are a little more forgiving.

3 Continue to fill in the shape with dots. Pause every so often to ensure you are not inadvertently creating a pattern, as you are aiming to create a random, but evenly-spaced effect. Make sure you achieve a crisp and well defined perimeter shape, keeping the dots evenly spaced around the edges.

4 Change to your next colour and repeat the process, building up a second, evenly-spaced layer of dots. Wherever possible, attempt to avoid the first layer of dots. There is, however, no need to be obsessive – decorating your lettering should be fun!

5 Continue until the shape is filled with the second colour.

Using a brush

A brush can be used for this stippling technique, though it will take longer to complete. As a result, I suggest that it is best used for letters of 40mm (1½in) height or smaller.

To make sure the dots you make are as circular as possible, load the brush with a reasonable amount of liquid, use a light touch, and hold the brush upright as shown to the right.

A tilted brush, a heavy touch, or too little paint requires more pressure to deposit the dot, which can lead to irregular pointed shapes.

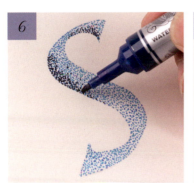

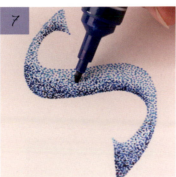

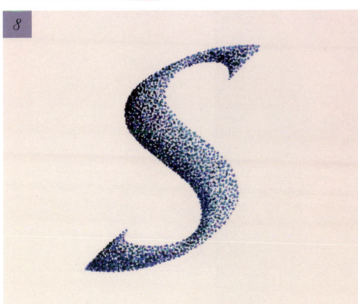

6 Up until this stage, there has not been any need to consider areas of light and dark, but from now on, each successive stage relies on building the shadow areas to create the illusion. With the third and successive colours, the shading effect can begin, so it is important to decide upon the direction of a light source (in this case, at the top right). Start to build up dots on the sides away from the light source, (i.e. the lower left) to begin creating the shadow effect. At this stage you will inevitably need to work on top of previously laid dots.

7 While concentrating the new colour on areas away from the light source, help to blend in this new colour by adding the occasional dot or two away from the shaded areas. As you move away from the perimeter of the letter, gently tail off the dots on the inner boundary to avoid creating a hard edge in order to complete the perception of a rounded form.

8 Continue to build up the depth of shaded areas with successive layers and colours, each time filling a smaller and smaller area, eventually filling and obliterating the white paper at the point of deepest shading.

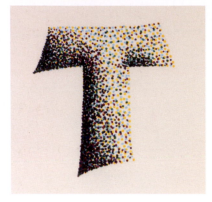

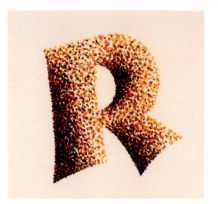

Varying this technique

Pointillism (see page 98) can be readily applied to any letterstyle, forming the whole letter profile as above, or as an infill within a drawn shape such as the N shown to the right. In each case, the same principle of light and dark has been applied.

Some alphabets, particularly bolder styles like the neuland T (above left), work particularly well with the stippling technique as there is more space with which to suggest roundness. As a result, these styles are good with which to begin and to practise. With more confidence, skill and experience, you will be able to work the pointillist technique very well on finer scripts.

T-shirt design

A design made for the Calligraphy and Lettering Arts Society's Festival of Calligraphy. As you can see, the effect works equally well with black and white as in full colour.

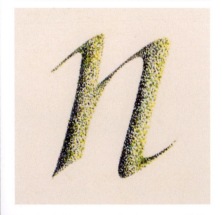

Different styles

The technique works well on almost any script type, from thick and blocky styles to more elegant and flamboyant letterforms.

Christmas card

The stippling technique is so striking that it needs very little additional embellishment to make a fantastic greetings card.

C is for...

Decorated lettering is perfect for signage, where it helps to instantly pass the message with a touch of humour. The overall design is unified by a range of similar colours, but contrast and interest have been created by decorating the C in an entirely different style to the rest of the text.

Playing with pastels

Pastels are a very versatile medium and have been a favourite of many well-known artists, including the Impressionist painters Édouard Manet, Edgar Degas and Pierre-Auguste Renoir. They allow you to achieve exciting results by using an eraser to rub out parts of an area covered by pastel to create your design. The range of delightful effects can be greatly increased by using simple torn or cut masks in the form of paper or thin acetate, to protect their working surface.

Hard pastels are made by mixing dry artist pigments with water and binder, usually gum tragacanth and forming them into stick form, allowing you to layer and blend colours to create a stunning result, be it a soft or vibrant look.

Pastels offer an uncomplicated way of adding instant colour to the background of a piece of calligraphy; but they can also be used to create the letters and other shapes themselves by rubbing pastel dust through cut acetate stencil shapes.

Above, left to right:

The template for this capital P was prepared from clear acetate. Note the small gaps which resulted from the need to hold the central counter in place (see page 109). While functional, these 'pathways to safety' can be decorative, too. Pastel dust was firmly rubbed through the template until a crisp image was achieved, then the template was repositioned and coloured twice more. A second template, large enough to cover the three letters and a margin around them, was placed over the letters and pastel rubbed in an outwards direction. Details were then added including dark central lines in watercolour and dots as the focal point.

The frame for the freestyle capital Q was made by laying an acetate template with a heart-shaped hole cut in it, and drawing pastel inwards towards the centre. Fine radiating lines were then removed from the pastel with strokes of a clean, sharp-edged eraser.

The paper-masking technique shown on pages 106–107 was used for the background of this Roman capital R. Once the background was complete, the letter was added, along with some extra decoration.

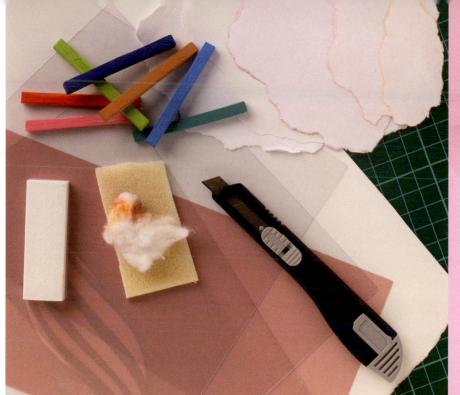

You will need

Hard pastels

Clean plastic eraser

Craft knife

Cutting mat

Scrap copy paper

White hot-pressed paper
300gsm (140lb)

Coloured paper

Thin acetate

Cotton wool or
household sponge

Pastel care

Clean off each pastel stick after you use it. Use a dry towel or paper towel to remove any other pigments picked up. You can also help keep your sticks clean by storing them with uncooked rice.

Pastel pigments

The pigments used in gouache, watercolour, oil, acrylics and pastels are the same. It is the binding agent with which they are combined that gives them their particular characteristics. Pigments come from a variety of natural and synthetic sources.

Paper masking

This technique uses pastels with simple copy paper masks to create backgrounds with a delightful sunburst effect. The central space can be written over afterwards. Alternatively the whole procedure could be easily prepared on top of an already written word or verse, as the copy paper will protect your existing work. This technique does not require fixative, as the pastel will have been well ground into the surface. If in doubt, test on a spare piece of the paper you will be using.

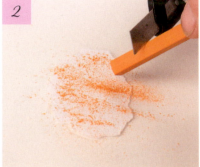

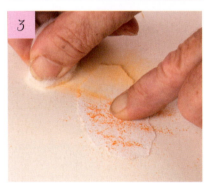

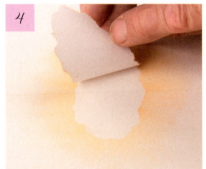

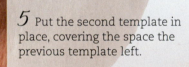

Keep still

Take care not to move the stencil, especially if you need to change hands, or the effect may be smudged.

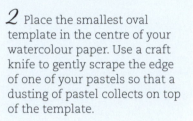

1 Tear three successively larger rough ovals from cartridge paper or similar thin paper.

2 Place the smallest oval template in the centre of your watercolour paper. Use a craft knife to gently scrape the edge of one of your pastels so that a dusting of pastel collects on top of the template.

3 Holding the template in place with a finger, use a small amount of cotton wool to smudge the pastel away from the centre of the template, and into the surface of the paper.

4 Work all the way round the template, using firm strokes radiating out to grind the pastel into the watercolour. Carefully remove the smallest template.

5 Put the second template in place, covering the space the previous template left.

6 Using a different-coloured pastel, repeat the scraping and rubbing procedures.

7 Carefully remove the template.

8 Place the largest template over the 'hole' of clean paper, as before. When scraping, you can mix colours by simply using more than one pastel. Here I am using blue and red pastel to make a purple effect. Add a fair dusting for larger templates. Be careful if you need to scrape more pastel – you can spoil the effect if you accidentally move the template part-way through the technique.

9 Replace the smallest template over the hole of clean paper, then use a hard-edged plastic eraser to 'draw' radiating fine lines outwards from the centre.

10 Continue all the way round the template, then remove the template to finish. The paper is now ready for you to write upon it.

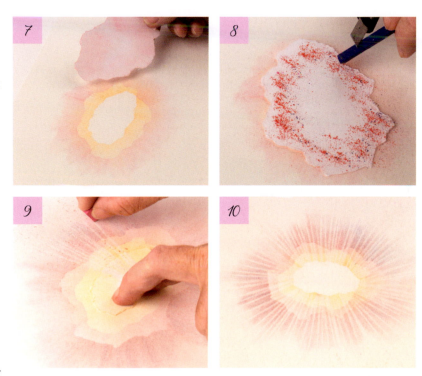

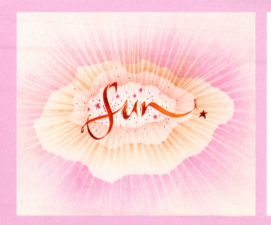

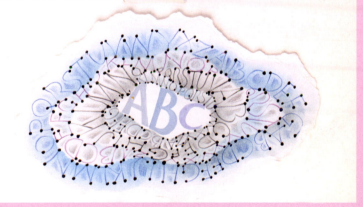

Varying this technique

I love using this on birthday cards, as you can readily write a simple greeting, name or numbers in the middle. Several examples of these variations are illustrated here, and I encourage you to experiment with the technique – enjoy playing!

Masking for wavy backgrounds

There are many variations of simple paper masking, so enjoy experimenting with it with a technique like this one, which will produce an interesting shape, perfect for consistency with unusual lines. You can use a variety of colours, or just one – as you wish. The technique can be repeated as much as you like. Why not try an entirely circular design?

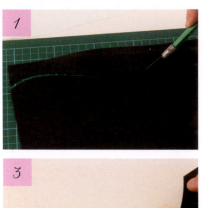

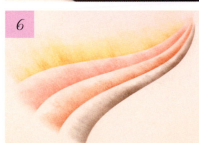

1 Use a craft knife to cut through scrap paper to make a wavy edge.

2 Place the scrap paper on top of your paper, with the wavy edge near the top. Use a craft knife to scrape some pastel dust along the wavy edge.

3 Use cotton wool to smudge the colour over the edge of the template and onto the watercolour paper. Work along the edge, then use a finger to hold it in place on one side. Carefully rotate the template a little, around your finger.

4 Add more pastel dust to the edge and repeat the smudging.

5 Place your finger in the same place as before, and rotate the template a little more.

6 Continue as many times as you like, then remove the template to reveal your background, ready to write upon.

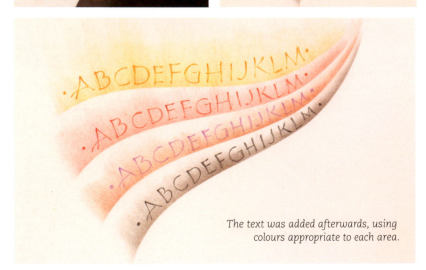

The text was added afterwards, using colours appropriate to each area.

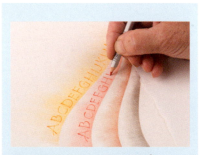

Protect your pastel

The pastel is stable enough to take coloured pencils, or even gouache. Nevertheless it is a good idea to use a spare piece of scrap paper to sit under your hand as you write.

Acetate templates

Acetate templates take a little time to prepare and cut, but they can be re-used again and again, so it is time well spent. It is important to ensure that counters (the enclosed middle parts of the letterforms) do not drop out when preparing your templates, so some practical and decorative channels are added between shapes to ensure the letter remains exactly as it should. I call these 'pathways to safety'.

1 Draw your required letter out using a 2H pencil. Add some additional lines across the shape that join the counter space to the outside of the letter. These are decorative, but will serve a function. Make sure they are not so bulky that they destroy the shape of the letter, nor so fine they will not support the acetate template.

2 Use a fine eraser to remove the small lines at the edges, so that you create fine channels through the letter.

3 Place the paper on a cutting mat, and use masking tape to secure a sheet of acetate on top. Use a craft knife to cut out the template. Avoid the channels when you reach them. Try to think of the letter as made up of small shapes broken by the channels, rather than a complete letterform, as you cut.

4 This completes the template.

5 Use a craft knife to scrape your pastels on to scrap paper, creating a small pool of pastel dust. Use two or three colours.

6 Rub a piece of cotton wool into the pile, to load it with pastel colour. Gently shake off excess colour.

7 Place the acetate template on your paper. Holding it in place firmly, rub the loaded cotton wool over the template.

8 Continue working until the letter is completely covered.

9 To strengthen the colour, you can rub the cotton wool over the pastel stick, and dab it on it places to add some variation.

10 Carefully remove the template to finish.

Secret of success:
The quality and success of the rubbed pastel result depends on a cleanly cut template. Cross-cut the angled corners to ensure the removable part comes away cleanly: pulling uncut parts leads to jagged edges.

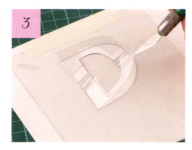
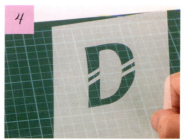

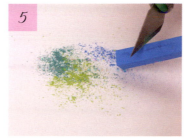
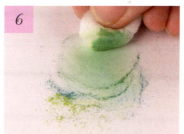

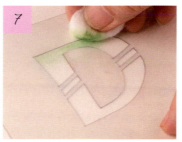
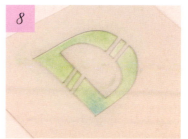

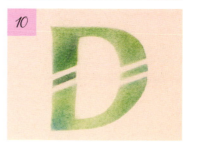

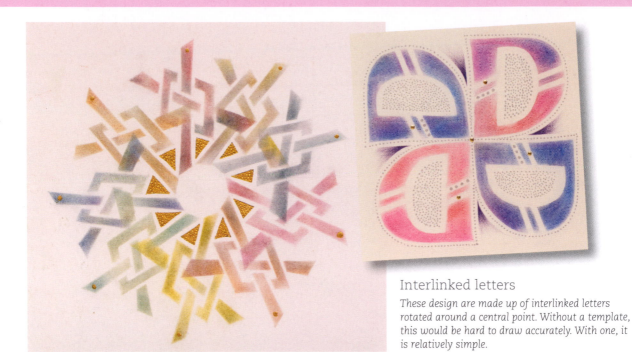

Interlinked letters

These design are made up of interlinked letters rotated around a central point. Without a template, this would be hard to draw accurately. With one, it is relatively simple.

Black and white

A little white pastel dust was ground into the surface of the black paper, before I used a clean eraser to 'draw' lines on the surface, by removing some of the pastel. I experimented with writing on top for contrast, and also spattered white gouache using an old toothbrush to create a distant starry sky effect.

Bumblefrog

Written for Aimee, then aged five, who was in her garden looking for baby frogs (tadpoles) and told they were as tiny as a bee! Pastel was rubbed into the background after the writing was completed, then the coloured pencil illustration added

The Bumblefrog

Is it a frog…
 or is it a bee?
I really don't know
 till I find one you see!
He's extremely small
 with a wriggly nose
 hopping and
 buzzzing…
 wherever he goes!
I DO hope I see him
 about that business
 of his…or I'll NEVER
 find out what
 a bumblefrog is!

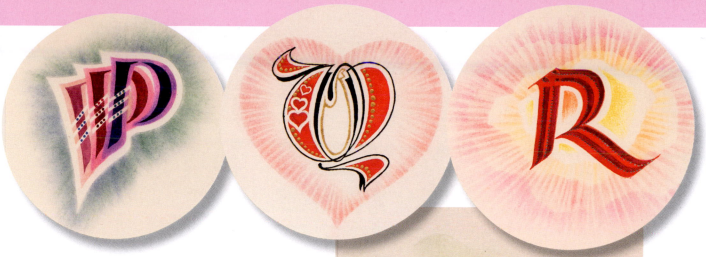

Pastel examples

Pastels are a versatile medium that work as well for backgrounds as they do to decorate letterforms themselves.

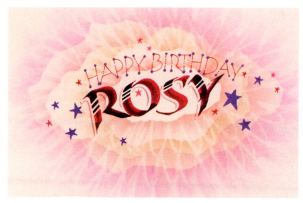

Birthday card

The paper masking technique creates a striking result. Perfect for setting off simple messages.

The WORLD'S RAINFORESTS GIVE US CLEAN AIR AND WATER HOUSES THE BIGGEST COLLECTION of *Life on Earth*

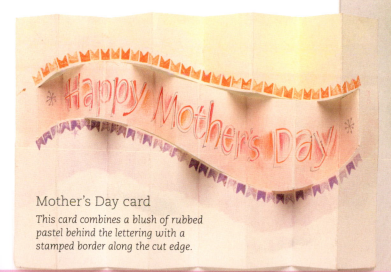

Mother's Day card

This card combines a blush of rubbed pastel behind the lettering with a stamped border along the cut edge.

Life on Earth

Pastel was rubbed across the writing, the sunbeams were lifted out using an eraser, and finally a large cheeseplant leaf was embossed from the reverse side of paper.

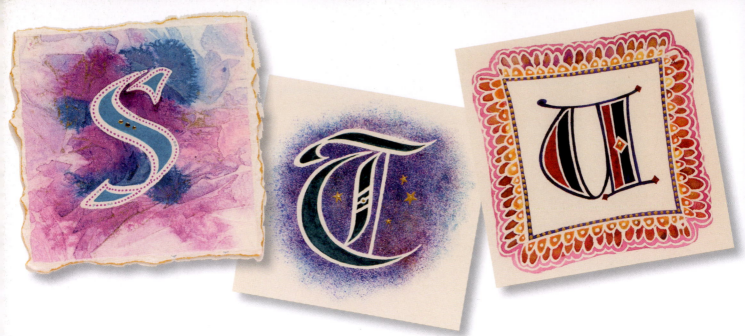

Masking fluid and wet colour

Masking fluid (also called liquid resist or drawing gum) dries to a water-resistant film which protects the paper's surface. This provides a gateway to a host of applications and a wealth of opportunities to work spontaneously with wet colour.

Large or small letters can be drawn using a pen loaded with masking fluid, or it can be liberally spattered from an old toothbrush onto the paper. Once dry, random washes of colours can be applied freely over the top, resulting in exciting backgrounds.

Delightful borders can easily be created by drawing lines using a pointed nib, which will act as barriers to hold colour in position. The simplest of designs can produce exquisite results and experimentation is a great way to explore this medium.

A clean start

Do not be tempted to shake up or mix in lumpy old masking fluid: it does not usually work, as the fluid does not have a very long shelf life. Treat yourself to success by investing in some fresh masking fluid.

Above, left to right:

The roman capital S was drawn using masking fluid applied with a no. 5 Automatic pen. Once dry, the whole area was wetted with clean water and coloured inks and bronze powder were dropped in and allowed to mix. Plastic food wrap was then laid over the wet surface and moved to form creases to hold pockets of colour. Once dry the food wrap and masking fluid were removed and extra decoration added with gold gouache and watercolour.

The gothic capital T was prepared in a similar manner, but decorated using sponging as described on pages 114–115. I could have left the letter blank, but again chose to add further colour and finally enhanced the background with a few stars painted on in gold watercolour.

The frame around this lombardic capital U was freely drawn using a pointed pen loaded with masking fluid. Once dry, I loosely brushed over their surface with watercolour. The letter was drawn in first, but could equally have been added later.

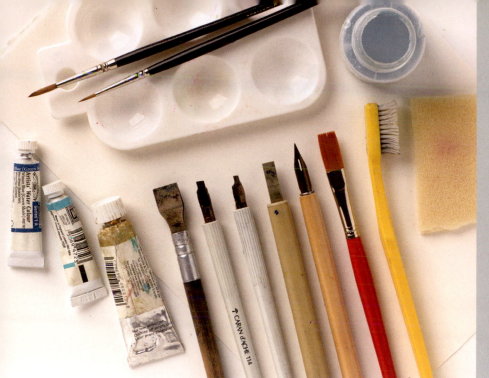

Starting out

Practise freely drawing lines or writing letters and words using different sizes of nib, getting used to recognising how often you need to clean your nib to achieve a continuing good flow. The fluid can become 'gloopy' quite quickly, as you are literally writing with liquid rubber!

Keep in mind that the paper colour you are covering with resist is the colour that will show on removing the dried fluid, where colour has been applied over the masking fluid.

Check your paper

Do trials on your chosen papers to check the dried masking fluid is easily removable without damaging the paper surface.

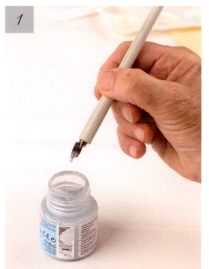

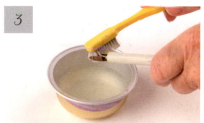

1 Masking fluid will work with any clean steel nib. Dip the nib directly into the masking fluid so that it covers the front of the nib and loads it.

2 The pen can now be used to write exactly as for ink, paint or any other fluid. You will need to allow the masking fluid a few minutes to dry completely before you work over the top of it.

3 Clean the nib as soon as is practical. Use an old toothbrush and water to gently scrub away the masking fluid.

Masking and sponging

Sponged backgrounds are a delightful way of adding texture and colour to a background – and used over an area of dried masking fluid, you can create striking results. Using closely woven foam such as that used for artificial household sponges results in the most delicate finish.

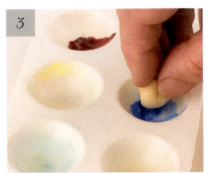

1 Use an Automatic or large edged pen to write a large letter on your watercolour paper with masking fluid. Allow the fluid to dry completely.

2 Tear off a small piece of close-textured artificial sponge and wad it into a rounded shape.

3 Prepare two mixes of gouache, working them up with as little water as possible, so that the working puddles are much drier than usual. Pick up some of the first colour with the dry sponge.

4 Dab away the excess paint on some scrap paper until you achieve a delicate finish.

5 Begin to make short, firm, dabbing motions to stamp the colour over the letter. Turn your hand and move the sponge as you work to avoid inadvertently printing a pattern. Reload the sponge when necessary, dabbing off the excess each time before applying it to the letter.

6 Continue sponging round the profile of the letter to build up the background texture. It is important to work right up to and over the masking fluid.

Good coverage

Ensure maximum coverage over and around the edges of the dried masking fluid so that a crisp result is achieved to the letter shape on removal of the masking fluid.

Watercolour or gouache?

This technique works just as well with watercolour in place of the gouache.

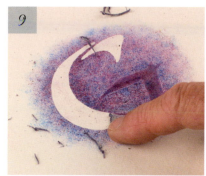

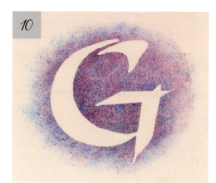

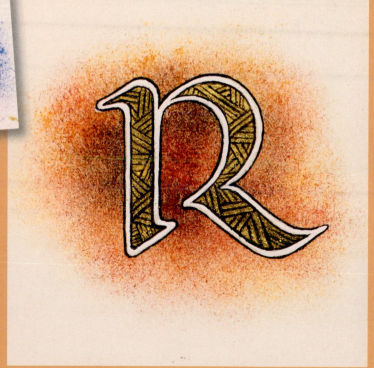

7 Continue sponging around the letter to build up a shape suggested by the form of the letter. This capital G works well in the middle of a loose circle, but you should feel free to build the background into a square, rectangle, or whatever shape fits well with your design. Sponge more lightly away from the letter to create a fading edge.

8 Use a new piece of sponge to begin applying the second colour in the same way, working right over the wet underlying gouache. Allow to dry thoroughly before continuing.

9 Rub away the masking fluid using a clean finger.

10 The finished letter is now ready for further embellishment.

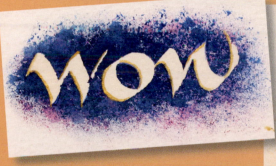

Varying this technique

Once removed, the clean white surface left by the masking fluid can be decorated further. For the 'wow' above, I have applied gold gouache as a shadow to the letters.

On the uncial R to the right, I have painted a mixture of black gouache and dilute PVA glue, leaving just a fine white border. I then gilded and added sgraffito patterns as described on pages 122 and 124. You can paint stripes of colour, draw with fineliner pens, in fact experiment with any method that does not damage the dried rubberised surface until you are ready to remove it. Some approaches will work better than others, but there is only one way to find out – experiment and enjoy!

Masking and layered washes

Using multiple layers of masking fluid and successive layers of colour, without removing the dried fluid, can create a beautiful effect. It is not easy to write over an increasingly rubberised surface with a metal nib, as it is easy to catch the previous layer of dried masking fluid, so the lightest pressure is needed. However, the resulting pattern will make it all worthwhile.

1 Write out your phrase using a steel-nibbed pen and masking fluid. Prepare a working puddle of your first watercolour paint while you allow the masking fluid to dry. Using a large, soft, flat brush, wet the surface of the paper with clean water. Work right to the edges of the paper, regardless of how small an area of colour you require. This will help create a soft edge as the colour will become weaker and weaker as it spreads out across the wetted surface.

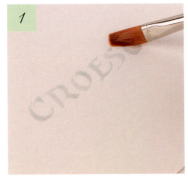
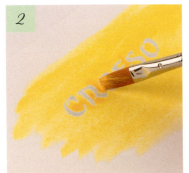

2 Pick up the first colour with the brush, and paint right over the lettering and surrounding area. Pick up a little more paint with the corner of the brush and touch it into the wet paint around the letters to subtly strengthen the colour. The masking fluid will act as a barrier, helping to keep the stronger colour in place while it dries.

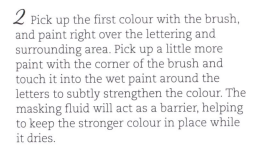
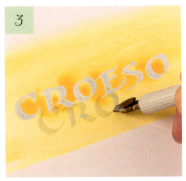
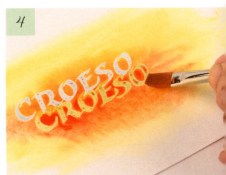

3 Once the paint has dried, write out your word again using the pen and masking fluid, straight over the colour wash and slightly overlapping the previous layer of masking fluid. Allow it to dry while preparing a working puddle of your second watercolour.

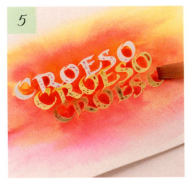
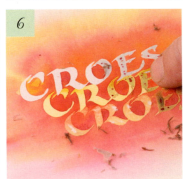

4 Wet the whole surface of the paper with clean water and the large brush, then lay in a wash of the second colour as before, working just over the lower part of the painting, so that some of the yellow remains visible at the top. As before, dab touches of the colour in and around the letters using the corner of the brush.

5 Repeat the procedure below the second set of letters with a third colour.

6 Once thoroughly dry, carefully remove all of the masking fluid using a clean finger.

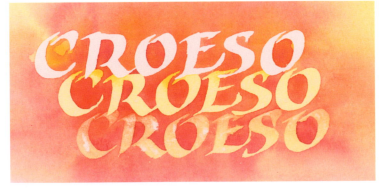

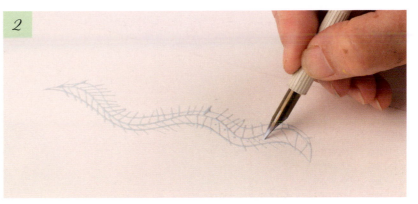

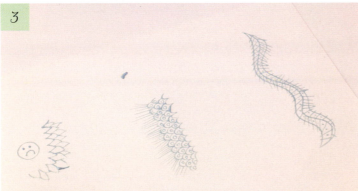

Quick masked borders

1 Pointed nibs are perfect for quick borders that give an attractive decorative effect. Load your pen with masking fluid exactly as normal (see page 113).

2 Use the pen exactly as you would with ink to draw a decorative border, varying the pen pressure to increase the flow if desired. Allow the masking fluid to dry thoroughly before continuing.

3 Enjoy experimenting with different patterns and shapes and allow to dry. Do not worry about the occasional 'blob'.

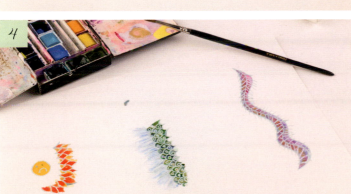

4 Use a paintbrush to run clean water over the area enclosed by the marking fluid, then lay in a wash of watercolour, including a hint of gold if you wish. Keep the colour within the shape to ensure a contained border. You can add other colours wet-in-wet if you wish.

5 Use a clean finger or eraser to rub away the masking fluid to reveal the completed border.

Speedy loading
For speed when loading your pen, you can dip the nib directly into the pot of masking fluid.

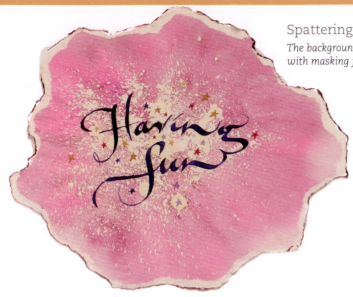

Spattering

The background of this example was spattered with masking fluid, resulting in an exciting effect.

Shadows

Gold shadows have been added to these letters to add a further eye-catching highlight to the clean paper revealed by the removal of the masking fluid.

Oceans

Made with the layered wash technique detailed on page 116, the colours I chose for this piece evoke the wording.

Fire fun

Red touches were added wet-in-wet on a yellow wash around the masked-out lettering. When removed, a striking fiery effect is revealed.

Coloured papers

It is important to remember that the masking fluid will preserve the colour of the paper on which you are writing – so whatever paper colour you use (or have coloured when working in layers) will be the colour that is revealed when you remove it.

Borders

Quickly made, simple borders and pattern such as those shown on this page add a delightful touch around your lettering.

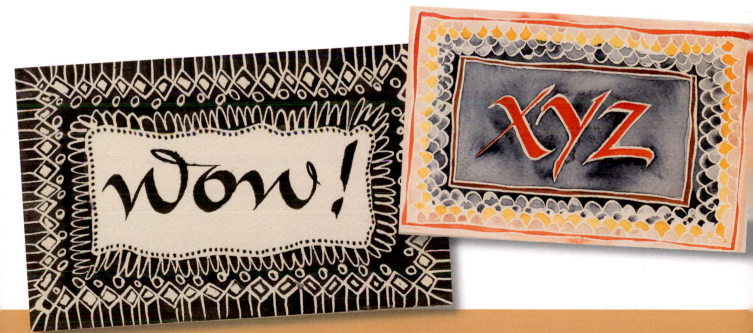

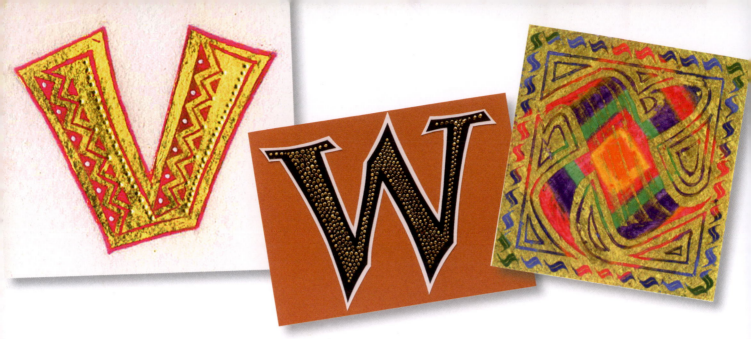

Colour, pattern and gold

The techniques in this chapter give me the most enormous pleasure. Playing with colour, pattern, gold and letters, being led in lots of different directions, all of them fun and exciting! The world of gilding is a very large one and we touch on just one aspect in this chapter, in the hope you'll want to eventually take it further. There are two main types of gilding: raised and burnished gilding, which is the traditional method using gesso (a traditional plaster-based surface) as the raised base cushion, and flat gilding, which is the area we gently dip our toes into. It is almost more exciting due to being more immediate!

To use gold leaf, there must first be a carefully prepared base glue to which it can adhere. There are a wide range of base glues to choose from, and we are going to work very simply using waterproof PVA, mostly in a diluted form, but also at full strength to produce tiny jewels of raised and gilded dots.

For the purposes of illumination, the gold you use should be twenty-two carat or more as this quality will stick to itself, allowing application of several layers if required, thus deepening the shine. Gold leaf can be purchased in loose leaf form or as adhered by pressure alone to a backing sheet, which is the type we use here. This is known as 'transferred gold leaf', as the leaf gold literally transfers from the backing sheet.

Above, left to right:

The neuland V was painted using a mix of gouache and diluted PVA. Once dry, gold leaf was applied and delicate patterns were scratched onto the gold surface using a curved blade, allowing the warm red colour to show through. Further indentations were added to enhance the design.

The versal W was lightly drawn out onto black paper and covered with a densely packed area of PVA dots. Once transparent and dry, the tiny domes were gilded and burnished to a jewel-like shine. The letterform was cut out, leaving a clear border of approximately 5mm (¼in) between the edge and the dots, and stuck onto white paper. I chose to again cut this white shape out and re-mount onto an orange background and loved the result.

The X was 'drawn' with a wide Automatic pen, scraping through a layer of leaf gold to reveal an array of colour made using oil pastels. I played with three different nibs to have fun with the sgraffito patterns I used here – it reminded me of my schooldays!

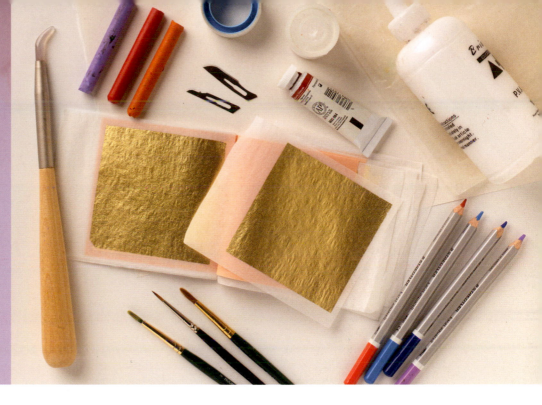

You will need

Hot pressed paper,
 250gsm (120lb)

Gouache paint

Non-soluble coloured pencils

Oil pastels

Low-tack removable tape

23.5ct transferred gold leaf

Agate burnishing tool

Waterproof PVA glue

Glassine (crystal parchment)

Curved scalpel blade

Nibs, brushes and mixing
 brushes

2H pencils

Preparing diluted PVA

Diluted PVA glue is used for flat gilding. Protect your best brushes when using PVA by dipping them into washing-up liquid and squeezing off the excess, which will leave a thin protective barrier in place.

1 Pour a small quantity of PVA into a container.

2 Gradually add a little water to cover the glue (do not dilute the glue below fifty per cent). Gently paddle a clean mixing brush around on the base of container, to mix the PVA and water while avoiding creating air bubbles. If some appear, try to drag them up the side of the container until they pop.

3 When mixed to the correct consistency, the liquid should be no thicker than single cream and must easily drop off the brush.

No froth

Smoothly blend the PVA and water together but avoiding introducing air to the liquid – a 'cappuccino' result is be avoided at all costs!

Glue quality

Do trials to check PVA quality – good quality waterproof PVA should shine when dry. Similarly, check to see that it will work well with the paper you are using. Some papers are very absorbent and this will give disappointing results. Look for a slight sheen on a dried mixture of PVA and paint.

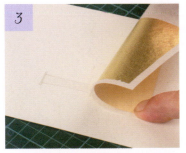

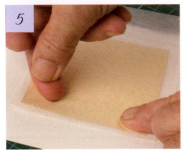

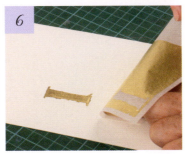

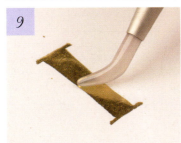

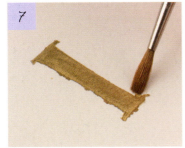

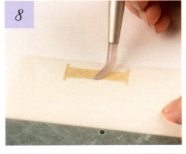

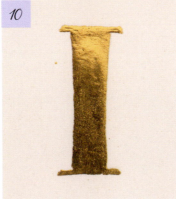

Gilding

Glassine is a smooth and glossy paper that will not stick to the gold, making it ideal for protecting gold leaf while you secure it to the paper surface.

1 Draw out your letter on hot-pressed paper using a 2H pencil. Use the prepared brush (see page 121) to apply diluted PVA to the letter, flooding in sufficient liquid to look smooth. Allow it to dry completely, to a shiny, transparent surface. Rinse your brush thoroughly as soon as you finish.

2 Place the paper on a firm surface, such as a cutting mat. Take a sheet of transferred gold leaf and place it face down over the area to be gilded.

3 Pinning the corner of the gold leaf firmly in place with one finger, draw back the sheet of gold leaf (this allows you to quickly place the gold over the correct area following the next step – speed is important).

4 Breathe out heavily two or three times onto the dried PVA shape (see inset), then quickly flip the gold back down onto the surface and press firmly to encourage the gold to adhere.

5 Immediately rub your upturned fingernail over the letter to ensure the gold is secure.

6 Gently peel back the sheet of gold to reveal the golf leaf on the letter. If any area is left uncovered, simply repeat the process. Gold leaf of 22ct or higher will stick to itself.

7 Use a soft brush to lightly brush away any pieces of gold clinging to the edges.

8 Lay a sheet of glassine over the letter and rub a burnisher over the area.

9 Remove the glassine and continue burnishing straight onto the gold.

10 Continue to burnish until you can see a reflection in it.

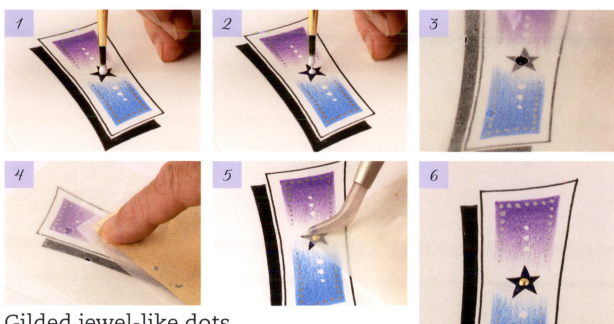

Gilded jewel-like dots

This brings a touch of class to your work! When adding a gold dot onto gouache or watercolour, the letter must be protected with a glassine mask in order to stop gold leaf sticking to the gouache or watercolour. The gold leaf is applied through a tiny hole cut out in the mask.

When applying pressure to the finished front surface of an embossed design, temporarily attach a sliver of card to the reverse side for protection from caving in when pressure is applied to the front.

1 Load a size 2 round brush with pure, undiluted PVA glue. Holding the brush vertically, touch the tip down where you want the large dot. Do not make the dot too large or it may sink in the middle.

2 Carefully draw the brush slowly up and away, leaving a small dome shape. Leave to dry thoroughly.

3 Cut a small hole in a piece of glassine and place it over the glue dot. This protects the rest of the letter from your breath, which means that the gold will not adhere anywhere except the glue dot.

4 Gild as described on the opposite page and brush away any tiny excess fragments of gold

5 Begin burnishing the dot through a protective sheet of glassine. This is more to protect the surrounding area so you do not inadvertently burnish any gouache or other materials.

6 Finish the burnishing carefully, working directly on to the gold.

Varying the technique

A similar approach is to cover a larger area of the letter in gilded dots. The method is exactly as described above, but the effect can be even more stunning.

The resulting dots will likely vary in size, but this can enhance the effect. Do try to avoid the dots touching if possible, as this can detract from the result.

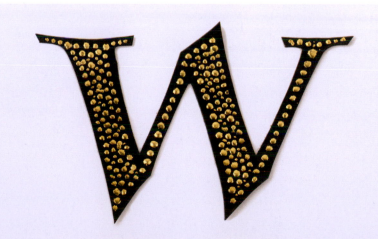

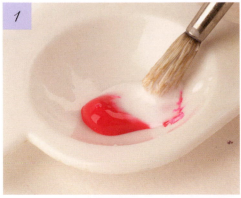

Sgraffito

Sgraffito is an Italian word meaning 'scratched'. This technique involves laying a preliminary surface, covering it with another and then scratching the second layer in a way that allows the initial surface to show through.

The curved blade used here is vital as its very shape limits the amount you can dig into the surface – we are definitely not digging trenches here.

1 Squeeze some gouache into a palette well and add a little of the diluted PVA. Use a mixing brush to gently mix the two together until the consistency of single cream. Work carefully so that you do not introduce air bubbles.

2 Draw out your letter using a 2H pencil. Load your brush with the mix of gouache and PVA and paint the letter. Rinse your brush thoroughly as soon as you have finished and leave the letter to dry completely. Dependent on the paper used, a slight sheen on the gouache may be visible.

3 Follow steps 2–7 of gilding (see page 122), remembering to repeat the process if any area remains ungilded.

4 Using a curved blade, gently scratch patterns into the surface of the gold to reveal the underlying colour.

5 You can finish with a simple border, or continue to scratch away more complex patterns. You can be happy in the knowledge that if things go pear-shaped, you simply apply more gold and start again, so enjoy and have fun!

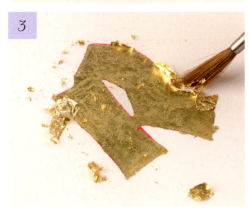

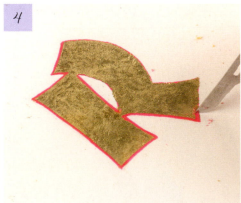

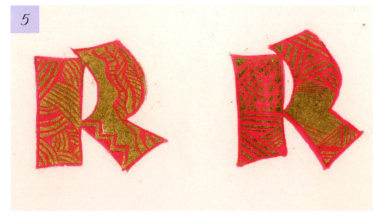

Varying and enhancing the technique

This page details some alternative approaches to the sgraffito technique. The safeguard in each of these methods, is that if it goes wrong, you can simply apply more gold and start again on top. Enjoy and have fun!

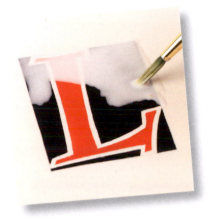
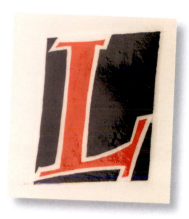
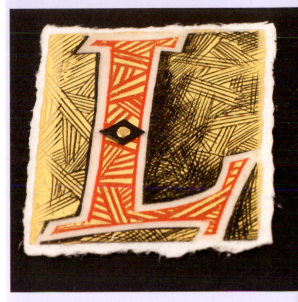

Sgraffito beyond the letter

Rather than concentrating on a single letter, you can cover decorated areas that have been painted using the gouache/PVA mixture with a second layer of diluted PVA, as shown above. Once dry, check for a shine, as illustrated in the central photograph. The main difference is the clear coating of glue can be gilded and burnished to a much greater shine than in the method described on the opposite page. This gives you the opportunity to use designs prepared using other media, such as non-soluble coloured pencils and waterproof inks, in place of the gouache/PVA mixture described opposite.

No pens

The gouache/PVA mixture will not pass easily through a nib, so it cannot be used with a pen.

Oil pastels and sgraffito

The strong, bright colours of oil pastels look wonderful when revealed using sgraffito patterns.

Run removable tape around the area you want to cover, then lay down a good deposit of oil pastels over the whole area (see inset). Next, place a sheet of transferred gold face down across the required area and press firmly to encourage transfer.

Oil pastels are slightly sticky, so there is no need to breathe on them before applying the gold. Remove the sheet carefully, then rub down through glassine.

With the gold in place, you can use a clean dry nib in the normal way to draw letters and patterns onto the gold, revealing the bright colours underneath. For the best results, use an edged pen nib which splits easily under pressure, as it adds interest to the scratched line. Remove the tape to reveal a clean edge.

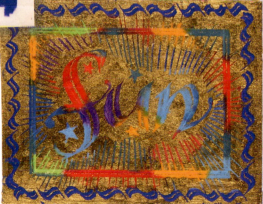

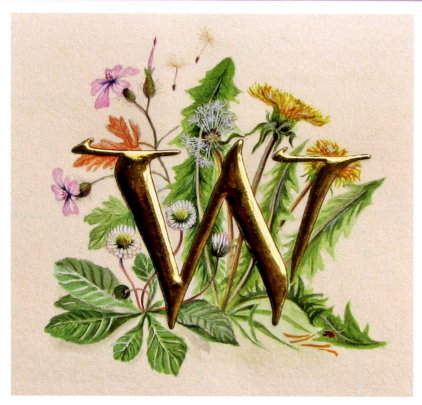

Wildflowers
This letter W shows the degree of shine achievable when raised gilding is done on a cushion of gesso instead of PVA. Compare the effect with the tiny little raised 'jewels' of gold on the lombardic capital E and the gothic S to the right. These used the PVA method described on page 125, which is able to achieve a similar level of shine to the traditional gesso approach, but only on very small areas.

Love
The gilded areas of the versal letters were completed first, before any colour was added. The gilded areas were then burnished to a bright shine before indenting the surface through glassine to create a beautifully textured, shiny area.

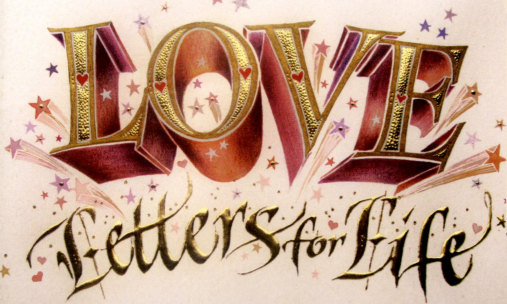

V, W, X

This is a page from the concertina alphabet book shown on page 5. The letters were painted using a gouache/PVA mix. Over this was laid a top coat of dilute PVA which was gilded before patterns were scratched through the surface.

Oil and sgraffito greetings card

The name was cut out of an area of random oil pastels gilded with sgraffito patterning, as described on page 125. Mounted on some handmade paper backing and with some small stars as extra embellishment, this makes a quick but effective technique for greetings cards.

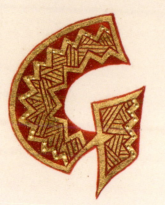

Indented sgraffito

The examples above and to the right show sgraffito work combined with indented dots. The bright and reflective nature of gold gives this technique an eye-catching result.

Lay glassine on the surface to be decorated and use the end of an embossing tool to enhance the decoration with indentations (as shown in the inset above). Press firmly on the surface to ensure a relatively deep, rounded dot.

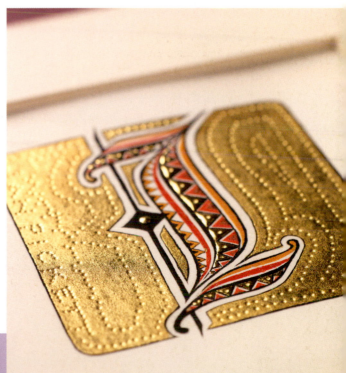

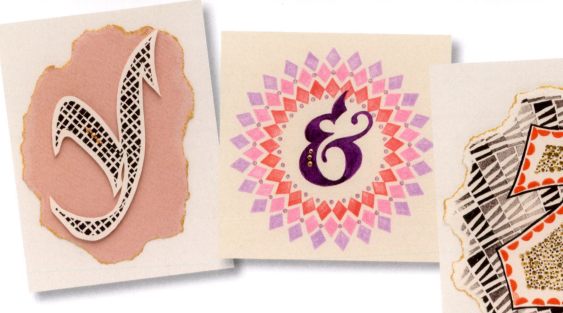
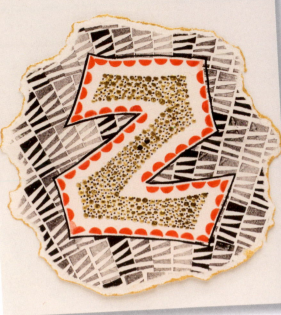

Stamping

A simple rubber stamp is a delightfully easy way of adding a small splash of colour to any design.

A shape cut into a firm, pliable eraser, pressed onto a pad of colour can be used for creating patterns, printing borders and much more. From a single additive print to multiple-stamped wrapping papers, hand-cut rubber stamps are versatile items in your repertoire.

The potential for pattern making using stamping is endless, so enjoy these simple and versatile techniques to the full. A word of warning before you begin: stamping can be addictive!

From left to right:

The italic Y was drawn calligraphically with double pencils (see page 95) before a template was made from low-tack masking film. A simple eraser was cut into a grid-shaped stamp (see page 130) and used to create the decoration through the stencil or negative part of the template (i.e. the hole). It was vital to stamp across the whole perimeter edge of the template to ensure an accurately formed letter. Once the template was removed, the letter and a small border was cut out and mounted onto a pink backing paper, using sticky fixers to lift the image slightly, casting a subtle shadow onto the backing paper.

The ampersand was drawn with my edged pen and allowed to dry, then three concentric rings of different colours were stamped around it using a shaped stamp (see page 131) in the form of a diamond. A few silver and gold embellishments add a sparkle. The head of the stamp being clearly visible enabled the position of the stamp to be more accurately judged.

Like the Y, the Neuland Z was stamped over a masking film template, but I used the silhouette or positive part (the actual letter shape) of the template for the Z. As before, I took care to print over the edge of the template to clearly define the letter shape before removing the masking film. Extra decoration was added in the form of an outline, further stamping with red semi circles and gilded dots made as described on page 123.

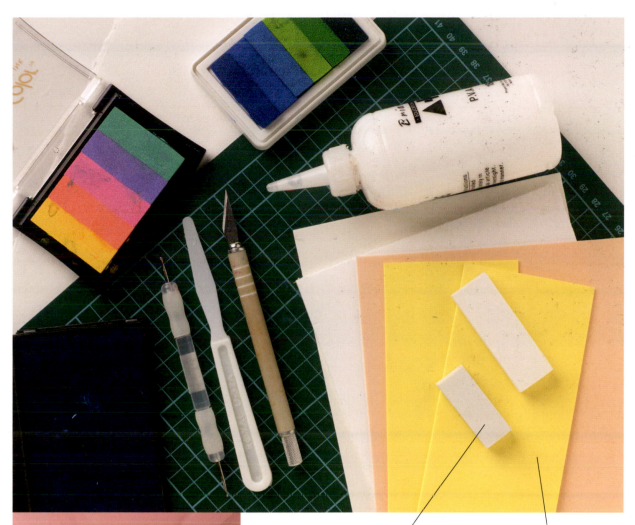

You will need

Clean, sharp-edged plastic erasers

Craft knife and cutting mat

Stamping pads

Papers in a variety of colours

Compass

Palette knife

Fun foam

Foam board

PVA glue

Low-tack matt masking film

Rubbing out

Square-edged plastic erasers make excellent stamps, as they maintain their shape and give clean prints.

Fun foam

Fun foam, sometimes called 'fab foam', is a soft and thin foam material that is available in packs or single sheets from large hobby stores. It holds its shape well and is slightly absorbent, which makes it ideal for stamping.

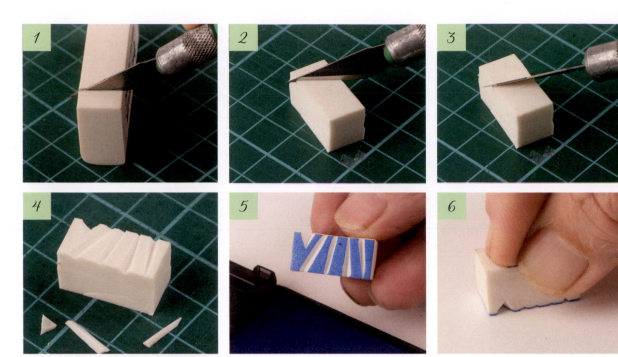

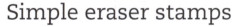

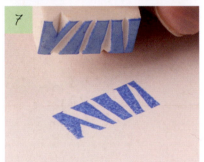

Simple eraser stamps

Simple patterns can be drawn onto the surface of an eraser or random cuts can be made. When inked and pressed firmly onto the surface, you can get some great results. Even more impressive patterns appear by not re-inking each time you stamp, as exciting tonal variations soon become evident.

1 Use a craft knife to cut approximately 1cm (½in) off the end of a plastic eraser. Try to keep the edge sharp.

2 Cut into the machined (smooth) end of the chunk of eraser at an angle of forty-five degrees.

3 Remove the blade and cut into the other side, removing a small angled chunk of the eraser.

4 Cut out a few more angled chunks from the same side to create your eraser stamp.

5 Load the stamp by pressing it firmly onto the ink pad.

6 Press the stamp down firmly onto your paper surface.

7 Lift away to reveal the result.

8 You can reload between stamping for consistent results, but you can create a fading effect by using the stamp repeatedly without reloading.

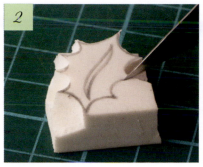

Shaped eraser stamps

The most dynamic results appear when a cut shape is printed and reprinted several times, creating an instantly forming pattern.

1 Draw your shape on the end of an eraser using a 2H pencil. Geometric shapes are considerably easier to cut, but even shapes like this holly leaf are possible.

2 Use a craft knife to carefully carve away the sections of eraser outside of the pencil marks to reveal the overall shape. This will let you place it perfectly each time, as the printing surface will not be hidden by overhanging parts.

3 Carve out any interior detail, like the vein here, to complete the stamp. It is important that only the shape remains on the original surface of the eraser. In addition, carve away any excess near the top, where you hold the stamp. This is so that you can easily judge positioning when you use it.

4 The stamp can now be used exactly as described on the opposite page.

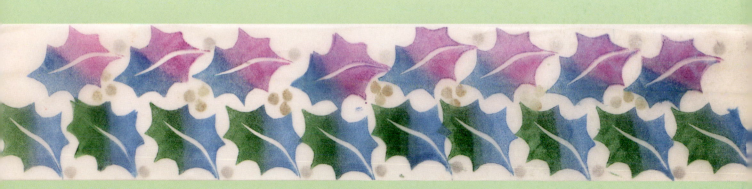

Border holly

This design was printed flat, then clipped in a circular shape and used as a napkin ring at Christmas. A shaped stamp gives you control as you can see exactly where the image will be imprinted. This makes it very useful for tightly-packed designs like this holly example, which would make an excellent marginal motif or bordering surround.

Fun foam lettering

Using fun foam, it is easily possible to create larger stamps of letters and other shapes. Combining a variety of shapes can be used to create a host of wrapping papers, napkin rings and borders!

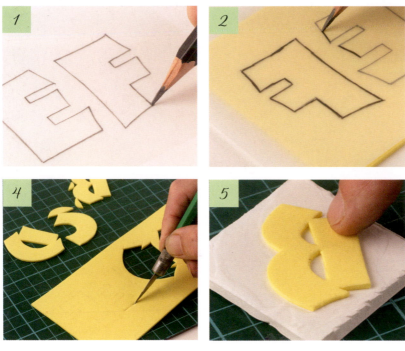

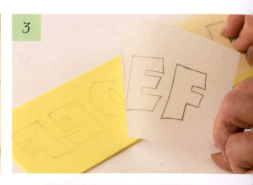

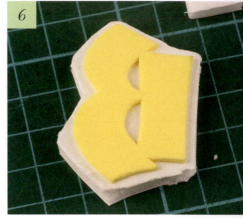

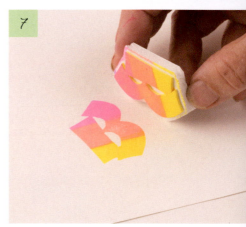

1 Use a 2H pencil to go over the lines of the letters you want to use on the front of the tracing paper. You can use the letters from the back of the book, or create your own.

2 Place the tracing paper face down on a sheet of fun foam and work over the back of the tracing to transfer the graphite.

3 Peel away the tracing paper to reveal the transferred letters.

4 Place the fun foam on a cutting board and use a craft knife to cut out the letters.

5 Smear neat PVA over a piece of foamboard and attach one of the letters to it. It is important that the letter is back-to-front so that it prints the correct way round.

6 Allow the glue to dry completely, then carefully cut away the excess foamboard using a craft knife.

7 Load the stamp by pressing it firmly onto an ink pad, then simply press it firmly down on your paper.

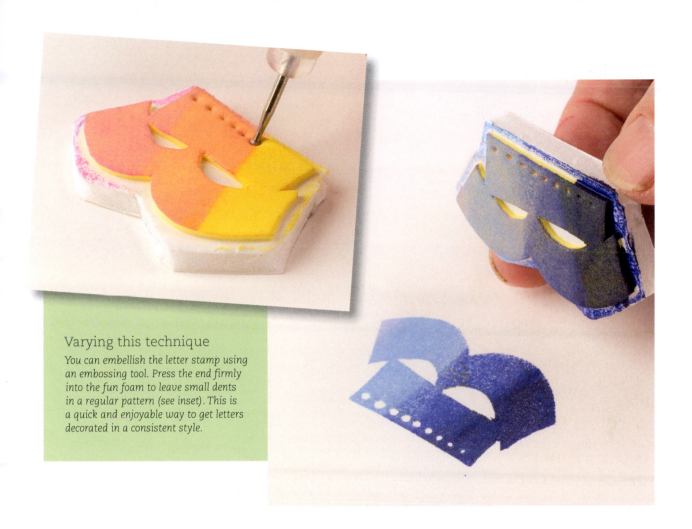

Varying this technique

You can embellish the letter stamp using an embossing tool. Press the end firmly into the fun foam to leave small dents in a regular pattern (see inset). This is a quick and enjoyable way to get letters decorated in a consistent style.

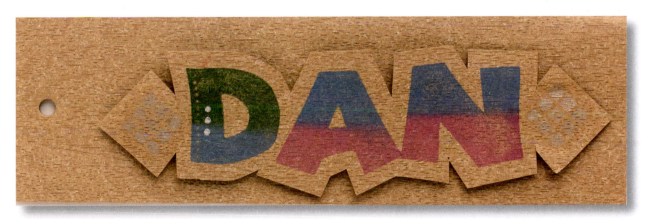

Gift label

The lettering for this label was stamped, then cut out and mounted on small sticky fixers.

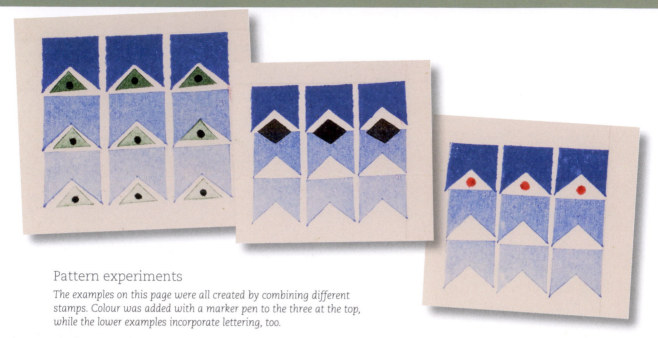

Pattern experiments

The examples on this page were all created by combining different stamps. Colour was added with a marker pen to the three at the top, while the lower examples incorporate lettering, too.

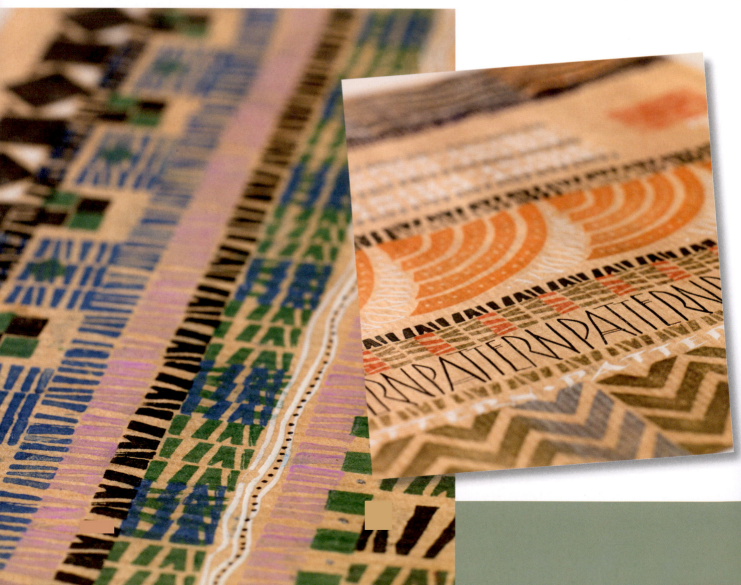

Table place name

The letters were stamped across card marked with a centre line. Starting at the exact point where the D crossed the line, the top half of the letters (including the counter spaces) were cut around, being careful not to cut along the centre line at any point.

Some additional space was left on either side of the name, which meant the card could be folded along the centre line and stand up. Be careful not to fold through the letter shapes when folding it, so that they stand proud of the top.

Gift labels

These are so easy to make for quick and delightful results. Pam's label uses the all-powerful but humble dot added with a gel pen!

For Rhys' label, I did not even have to cut the circle. I simply purchased a small pack of circular-ended erasers – perfect, as smooth circular shapes are more difficult to achieve.

Try stamping in a curve for variety, as in Pauline's label.

Patterned wrapping papers

A variety of prints, for which I used larger fun foam stamps combined with whatever stamps were to hand. I just had fun making patterns!

135

Templates and embellishments

The following section of the book includes examples of decorative flourishes, backgrounds and patterns for you to use in your decoration. They can be used with any of the alphabets earlier in the book, whether hand-drawn or pen-drawn.

Decorative flourishes
Simple shapes can be used as background, flourishes or templates for a number of techniques, from embossing to stamping.

Background ideas

The illustrations here show some examples of backgrounds for you to use as inspiration. Try colouring the light or dark parts using the techniques explained earlier in the book. You might also trace them onto card using the technique on page 132, then use them as templates or stencils (see pages 92–93 and 109).

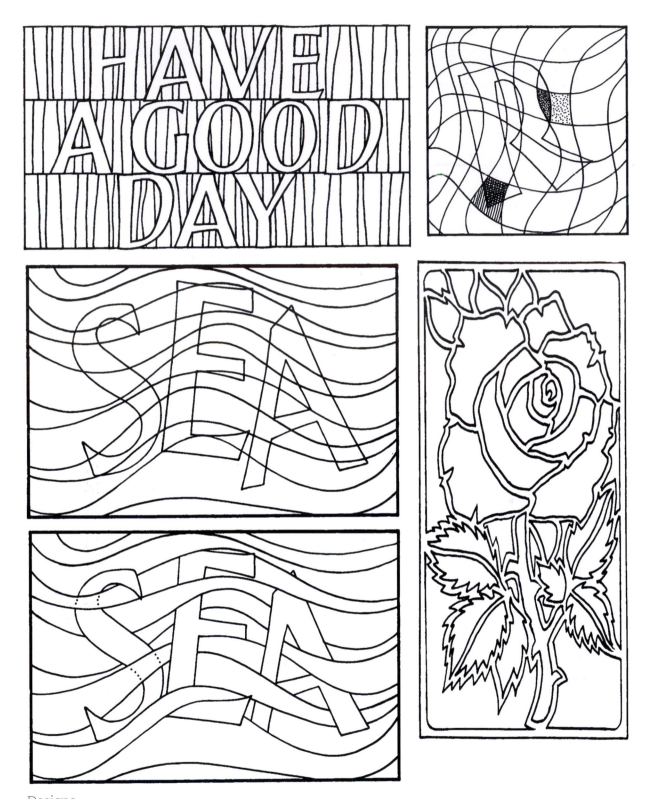

Designs

The templates on this page provide pattern suggestions for lifting out (see pages 76–77) and a simple rose design that could be used for a stained glass effect or as a background.

ABCDE
FGHIJK
LMNOP
QRSTU
VWXYZ

Linear shadows and inlaid jewels

Simple shadows and geometric shapes inside or alongside your letterforms
give a lift to any lettering. The examples here are shown on roman capitals (see
pages 28–29), but apply equally well to any alphabet.

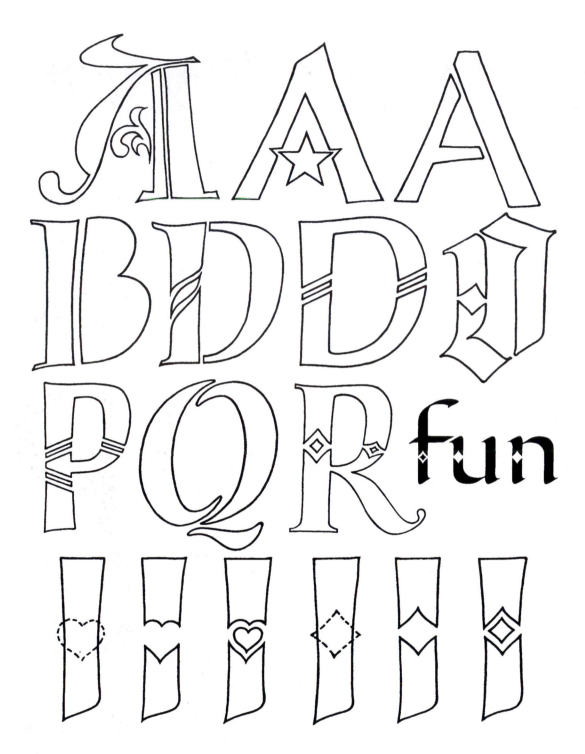

Counter space channels

To use stencils or stamping techniques (see pages 92–95) with certain letters, you need to connect the counter spaces with the outside using channels, as described on page 109. These pages show just a few examples of how you can approach this. As with the linear shadows on pages 86–87, the techniques can be applied to any letter in any style. The examples on the facing page show decorative channels used with modern uncials (see page 30–31). Note that the style looks very effective even on letterforms without counter spaces.

aBCDe
fChIJK
LMNOP
QRSTU
VWXYZ

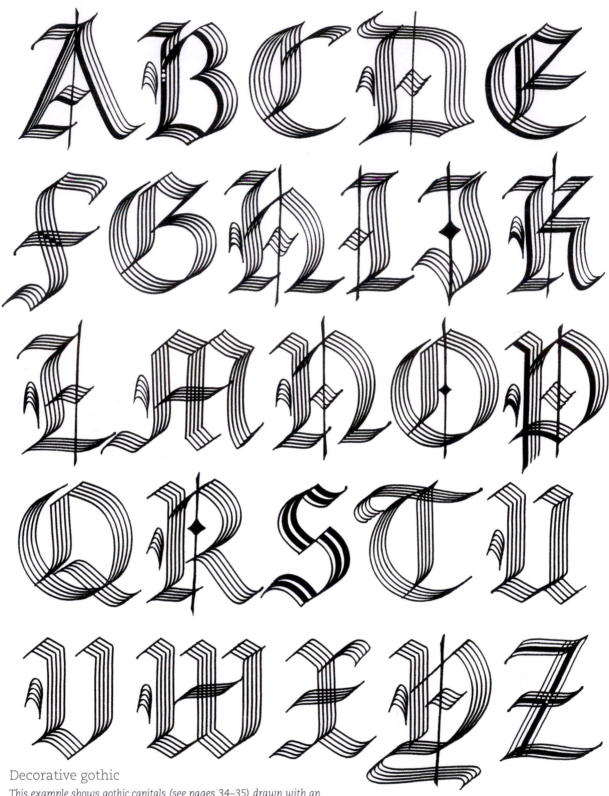

Decorative gothic

This example shows gothic capitals (see pages 34–35) drawn with an Automatic pen. Letters produced this way can have areas filled (as in the A, B, E, K, P, S and Z) and also coloured. For larger letters, try taping multiple pencils together in a similar way to page 95.

Glossary

Arch The joining tops of letters such as h, n, and m.

Ascender The portion of a letter that rises above the midline.

Ascender line The guideline for the height of the ascender.

Base line The main writing line that the body of the letter sits on.

Branching stroke A connection between downstroke and arch in italic styles.

Counter space The area enclosed within a letter; for example O has a closed counter space, C an open counter space.

Descender The portion of a letter that extends below the base line.

Downstroke A stroke directed towards the base line or descender line.

Ductus The direction and sequence of strokes which make the letter.

Family groups Groups of pen-drawn letters formed with similar stroke order and direction.

Flourish A non-structural embellishment added to a letter.

Hairline A very thin decorative line.

Inter-letter space The proportional spacing between letters dependent on their shapes.

Inter-line space A variable space between lines of writing – often twice the x-height to ensure clearance between ascenders and descenders.

Inter-word space Spacing between words, usually a tightly fitted 'o' of the letterstyle.

Letterform A term used in calligraphy and typography meaning the shape of a letter.

Letterstyles The general term for calligraphic or edged pen lettering styles.

Majuscule A capital or upper case letter.

Midline The guideline showing the upper boundary of a minuscule letter, not including ascenders.

Minuscule A lower case letter mainly occupying space between the base line and midline.

Nib-width The drawn width of any broad-edged tool held at ninety degrees to the writing line; used to determine the correct height of letters.

Pen angle Angle at which the nib meets the paper, relative to the base line.

Serif A small stroke which begins and ends a letter or part of a letter.

Slant line The forward slope of a letter, measured from the vertical.

Typography The technique and art of using and arranging type within the world of printing.

Waisting Also called entasis, this is the narrowing middle portion on styles such as versals.

Width groups Groups of similar width letters relative to their height and compared with a square. These are particularly associated with pen-drawn roman capitals.

x-height The measured space between the base line and midline regulating the height of the minuscule letter, not including any descending or ascending portions.

A final definition

The glossary above covers most technical terms used in calligraphy, but I would like to offer one more:

Mistake A great opportunity, which allows reassessment!

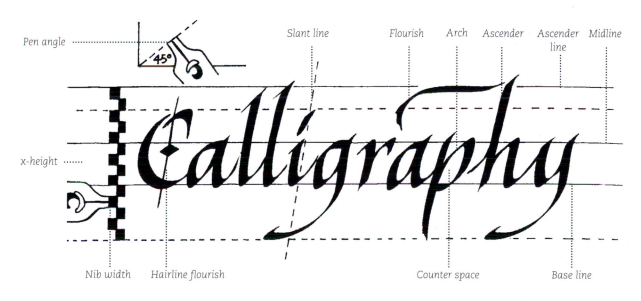

Pen angle · · · · · 45°

Slant line Flourish Arch Ascender Ascender line Midline

x-height · · · · ·

Nib width Hairline flourish Counter space Base line

Index